★★★ THE ★★★
CIVIL WAR
PAINTINGS OF
MORT KÜNSTLER

✯✯✯ THE ✯✯✯
CIVIL WAR
PAINTINGS OF
MORT KÜNSTLER

CUMBERLAND HOUSE
NASHVILLE, TENNESSEE

THE CIVIL WAR PAINTINGS OF MORT KÜNSTLER
VOLUME 1: FROM FORT SUMTER TO ANTIETAM
PUBLISHED BY CUMBERLAND HOUSE PUBLISHING, INC.
431 Harding Industrial Drive
Nashville, Tennessee 37211

Text based on the writings of Rod Gragg, Mort Künstler, James M. McPherson, and James I. Robertson Jr. All art dimensions are presented height x width in inches.

Cover design by Gore Studio, Inc., Nashville, Tennessee

Library of Congress Cataloging-in-Publication Data
Künstler, Mort.
 The Civil War paintings of Mort Künstler / Mort Künstler.
 v. cm.
 Contents: v. 1. Fort Sumter to Antietam.
 ISBN-13: 978-1-58182-556-5 ; ISBN-10: 1-58182-556-0 (hardcover : alk. paper)
 1. United States—History—Civil War, 1861–1865—Pictorial works—Catalogs. 2. United States—History—Civil War, 1861–1865—Art and the war—Catalogs. 3. Künstler, Mort—Catalogs. I. Title.
 E468.7.K844 2006
 759.13—dc22 2006015631

Printed in China

1 2 3 4 5 6 7 8 9 10—10 09 08 07 06

To my dear Deborah

OTHER BOOKS BY MORT KÜNSTLER

Mort Künstler's 50 Epic Paintings of America

The American Spirit: The Paintings of Mort Künstler

Images of the Civil War: The Paintings of Mort Künstler

Gettysburg: The Paintings of Mort Künstler

Jackson and Lee, Legends in Gray: The Paintings of Mort Künstler

Images of the Old West: The Paintings of Mort Künstler

Mort Künstler's Civil War: The North

Mort Künstler's Civil War: The South

Mort Künstler's Old West: Cowboys

Mort Künstler's Old West: Indians

The Confederate Spirit: The Paintings of Mort Künstler

Gods and Generals: The Paintings of Mort Künstler

The Civil War Art of Mort Künstler

CONTENTS

FOREWORD

THE FIRST year of the Civil War was a frightening and often confusing time for Americans both North and South. The mere fact of the fracture of the Union after four generations of nationhood had many reeling. And then, with secession an accomplished fact, myriad new questions presented themselves. Would the separation of the seceded states be permanent? Would there be a new nation and government on the continent to co-exist side-by-side with what remained of the old Union? Would the two neighbors be friendly cousins or engage in a bloody family feud? Would there be a war of words and ideologies or a conflict of armies and men? Everything was predicted or imagined, nothing was certain, and in the end almost every expectation would be proven wrong.

Before the first guns fired, many in the new Confederacy expected that the North would leave them alone. The two sections had quarreled, and the South had gone its own way. The North would surely say "good riddance" and let them go. But then President Abraham Lincoln made it clear that he did not countenance the legitimacy of secession and that, when he took office in March 1861, he intended to be president of *all* of the states. Furthermore, he would use military strength to maintain possession and control of federal installations everywhere, including in the seceded states. The result was the

opening of outright war at Fort Sumter, in Charleston Harbor, South Carolina, on April 12, 1861.

But now that there was to be a war, what sort of war would it be? Would the North, forced to surrender the garrison at the fort, make no further attempt to coerce the South back into the Union? The raising of an army in and around Washington, clearly intent on marching on the Confederate capital at Richmond, Virginia, gave every evidence that Lincoln meant more than talk. But on July 21, on the banks of Bull Run, that army suffered a humiliating defeat. Again the questions arose. Would that be an end to it? Would the beaten Yankees return to fight again? In fact, in Virginia they did not, and for the next eight months there was a "phony war" in which virtually nothing happened east of the Appalachians.

West of the mountains, however, the war continued with ever-increasing ferocity, culminating in April 1862 in the battle of Shiloh, the engagement that finally answered the question about the nature of the war they were to fight: it would be the hardest, bloodiest, bitterest yet seen in the hemisphere. Meanwhile, Union Gen. George B. McClellan raised the largest army ever seen to date and moved it out of its bases in and around Washington and invaded Virginia once more, intent on taking Richmond. The result was a series of engagements and battles from Williamsburg and Yorktown to Seven Pines and then the fabled Seven Days' battles that resulted in the salvation of Richmond and the emergence of Robert E. Lee as the great Confederate army commander. Meanwhile, another rising legend, Thomas J. "Stonewall" Jackson, waged his legendary Shenandoah Valley campaign and made himself Lee's ablest lieutenant.

Hard on those victories, Lee took the war north to attack and defeat another Union army on the old Bull Run battleground in August, and then in September, Lee and Jackson crossed the Potomac River, moved into the North, and confronted McClellan along the Antietam in Maryland. It would be the bloodiest single day in American history, Lee's first defeat, and the long-awaited victory that gave Lincoln the legitimate pretext he needed for issuing his Emancipation Proclamation, thus transforming the war and creating a whole new set of questions that only the years ahead could answer.

At times we need to pause and contemplate these events beyond what we can read, beyond the crumbling black-and-white photographs of the period. Artists such as Mort Künstler present us with such moments when they create images that pique our curiosity by translating what we know into an image that opens our eyes to something more.

Künstler is one of the premier Civil War artists, not just of our time, but of all time. He researches every element in his compositions and has a rare gift for interpreting these facts through paint and canvas. Künstler conveys the drama and emotion that moved countrymen to take up arms against each other. In this small volume, he wields paintbrush and canvas to capture the width and depth of this era. The effort he exerts to flesh out significant moments, contemplative scenes, and dramatic combat scenes produces an almost three-dimensional window on this war that defined the United States.

The confidence with which South Carolina, Mississippi, Florida, Alabama, Georgia, Louisiana, Texas, Virginia, Arkansas, North Carolina, and Tennessee separated from the Union and then fought for that independence is easily seen in Künstler's *Moonlight and Magnolias, Blessing of the Sword,*

Charleston—Autumn 1861, and *Guns of Autumn*. The hard realities of the war come across in his *Winds of Winter, The Fight at Fallen Timbers, ". . . They Were Soldiers Indeed," With a Rebel Yell*, and *"Raise the Colors and Follow Me."*

The artist offers snapshots of shared private moments on several levels. In a similar way, Künstler offers us a backstage view of some unique moments during the war, whether they be in the Confederate White House or in the various headquarters in the field.

Mort Künstler adds to our understanding of the war by completing the story through images of the people and events in a way that reminds us of our national identity. In short, history comes alive in his paintings. Individuals well known to us by their deeds and writings are given dimension and character in Künstler's paintings. Whether the subjects of these works are field commanders or men in the ranks, Künstler's unique talent conveys their battlefield courage, their stamina in the field, and their devotion to their leaders and their cause.

William C. Davis

★★★ THE ★★★
CIVIL WAR
PAINTINGS OF
MORT KÜNSTLER

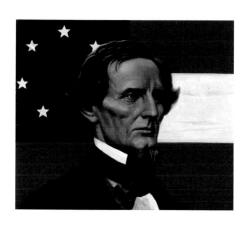

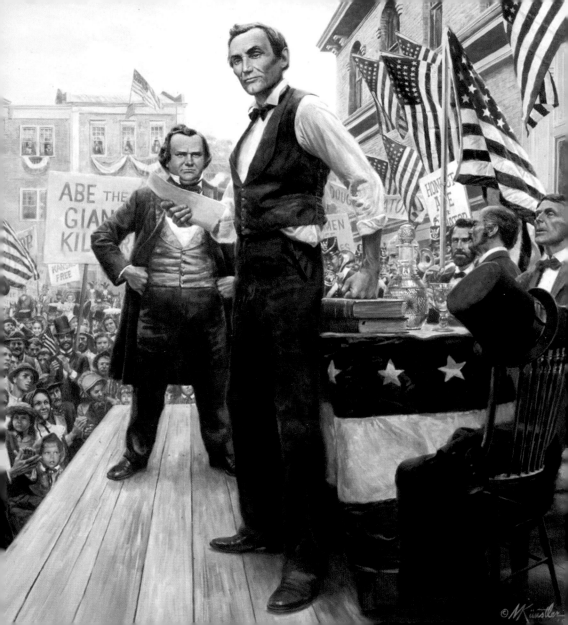

THE LINCOLN-DOUGLAS DEBATES

1987, oil, 30 x 30

DECADES OF dissent reached a climax in the late 1850s. Tension between the industrial North and the agrarian South stretched the bond of Union to its breaking point over the matter of the expansion of slavery into the new territories to the west and the eventual granting of statehood throughout this time. Northern abolition societies and antislavery groups pressed the matter in all walks of life. Legislation followed, and inevitably, the courts addressed the issue. When the Supreme Court in 1857 proclaimed that slaves had no rights that a white man should recognize, a lawyer and former politician from Springfield, Illinois, declared his candidacy for the Senate. He challenged the man who had tried to solve the slavery issue by compromise and redefining the matter as a local issue to be addressed by individual communities.

The campaign between these two men—Abraham Lincoln and Stephen A. Douglas—was punctuated by a series of seven public debates throughout Illinois in 1858. Physically, Lincoln was more than a foot taller than the "Little Giant." So I placed him in the foreground to exaggerate this contrast.

Oratorically, Douglas stirred his listeners with his fiery delivery. Lincoln's style was more plainspoken, appealing to the hearts as well as the minds of his listeners. Douglas narrowly won the election, but Lincoln found national recognition that eventually led to his selection as the new Republican Party's presidential nominee and his election to that position in 1860.

 ## SECESSION

THE 1861 call to arms was a challenge to defend the homeland, and thousands of men and boys thronged into recruiting offices. From Arkansas to Florida, Southerners enlisted to learn a new trade and defend their home states. Peaceful farmers were suddenly soldiers.

These are representative figures from the seceded states.

UPPER LEFT
JAMES LONGSTREET
SOUTH CAROLINA
Seceded: December 20, 1860

LOWER LEFT
WILLIAM BARKSDALE
MISSISSIPPI
Seceded: January 9, 1861

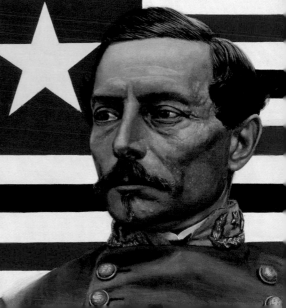

UPPER LEFT

JOHN HUNT MORGAN

ALABAMA

Seceded: January 11, 1861

LOWER LEFT

JOHN B. GORDON

GEORGIA

Seceded: January 19, 1861

LOWER RIGHT

P. G. T. BEAUREGARD

LOUISIANA

Seceded: January 26, 1861

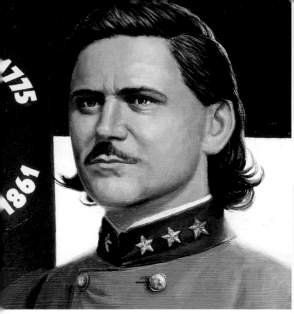

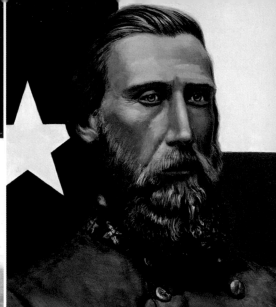

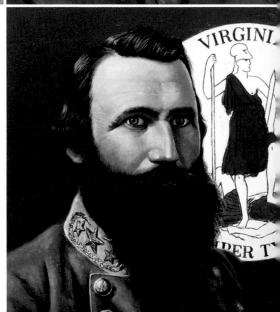

UPPER LEFT

ZEBULON E. VANCE

NORTH CAROLINA

Seceded: January 26, 1861

UPPER RIGHT

JOHN BELL HOOD

TEXAS

Seceded: February 1, 1861

LOWER RIGHT

J. E. B. "JEB" STUART

VIRGINIA

Seceded: April 17, 1861

But none of these states believed they could stand alone. So on February 4, 1861, in Montgomery, Alabama, the Confederate States of America was formed. One of its first acts was to name Jefferson Davis of Mississippi as its president. He would be the only president of the Confederacy. "All we ask is to be left alone," Davis declared.

One month later, Abraham Lincoln took the oath of office as the sixteenth president of the United States. "We must not be enemies," he asserted.

But the die was cast.

NATHAN BEDFORD FORREST
TENNESSEE
Seceded: June 8, 1861

JOHN S. MARMADUKE
MISSOURI
Seceded: October 31, 1861 (unofficial)

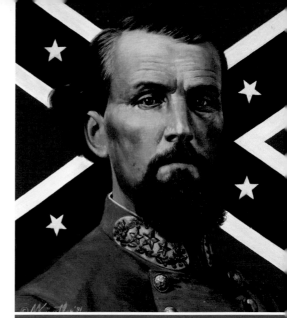

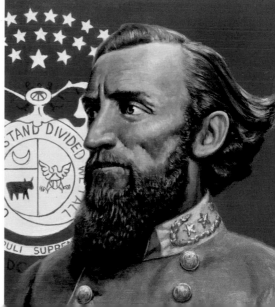

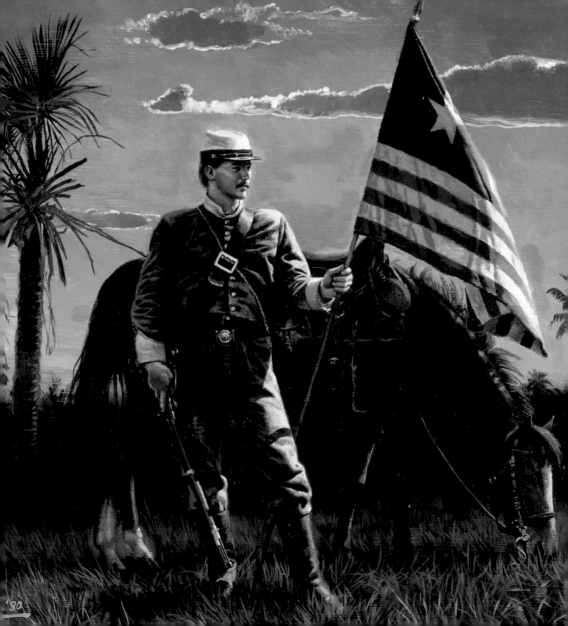

FLORIDA SECEDES

JANUARY 10, 1861

1990, oil, 10 x 11¼

BETWEEN THE secession of South Carolina and the inauguration of Abraham Lincoln, Southern states that followed the Palmetto Republic out of the Union began confiscating formerly Federal properties. Post offices and customhouses were one thing, but arsenals and forts were another. As the weeks progressed toward the reality of Lincoln's taking office, two tinderboxes smoldered. One in Charleston, South Carolina, namely, Fort Sumter. And the other in Pensacola, Florida, at Fort Pickens.

Florida seceded on January 10, 1861, the second state to leave the Union, but military preparations had begun shortly after Lincoln's election. A few days before formal secession, state forces began seizing arsenals and forts.

In a strikingly similar sequence of events, the Federal garrison at Pensacola moved from its mainland facilities to offshore installations, thus blunting Florida authorities' efforts to seize quantities of munitions and powder. While the navy yard at Pensacola was surrendered, Fort Pickens was reinforced and resupplied. This bold effort succeeded in depriving the South of full use of the best harbor on the Gulf of Mexico.

MOONLIGHT AND MAGNOLIAS

ARLINGTON PLANTATION
LAKE PROVIDENCE, LOUISIANA
APRIL 6, 1861

1997, oil, 30 x 46

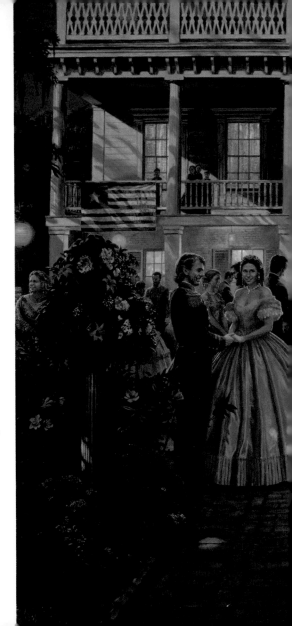

A STOLEN KISS! A farewell and a proposal of marriage at a secession ball in the weeks leading up to the war! These were the ideas that flashed through my mind when I first saw Arlington Plantation on Lake Providence in northeastern Louisiana. The home's owner visited my studio to gauge my interest in creating a Civil War painting incorporating his ancestral home.

After seeing photographs of the house, I realized this was a prime example of an antebellum mansion. Immediately I glimpsed the possibilities for an unusual painting.

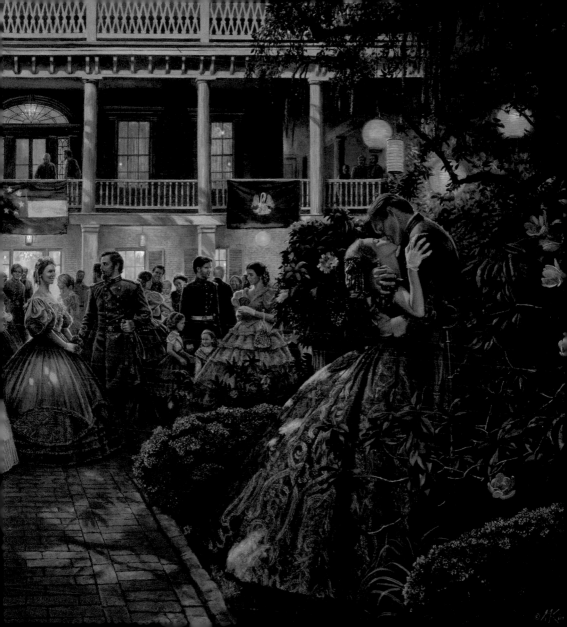

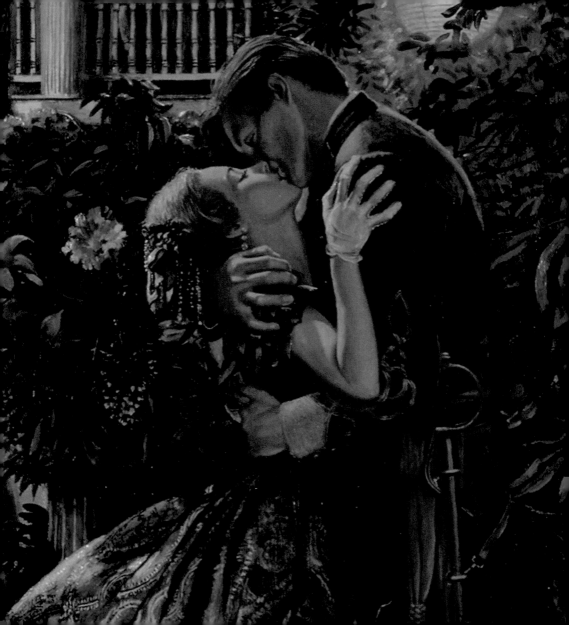

Arlington Plantation was originally built as a single-story house in 1832 for Mrs. T. R. Patten. It was later raised and made into a two-story manor house by Edward Sparrow, who was later chairman of the Committee on Military Affairs for the Confederacy; he also voted for secession in Baton Rouge on January 26, 1861. The house is now occupied by direct descendants of Sparrow, who have maintained its beautiful condition and are continuing a very successful program of restoration. They were gracious hosts and knew much of the history of the building. To this day, Sparrow Road in Providence leads to Arlington Plantation.

I learned that a grand ball was held at Arlington Plantation on April 6, 1861, and people from as far away as Baton Rouge and New Orleans attended. This gave me the setting I needed for my painting. What a great way to use the warm glow of the lights and Japanese lanterns so popular at that time to contrast the cool moonlight outside.

The center flag hanging from the upstairs porch rail is the first national flag of the Confederacy, the Stars and Bars. On the right is the pelican flag of Louisiana prior to secession. On the left is the Louisiana state flag adopted on February 11, 1861. It had thirteen stripes but alternated blue, white, and red stripes to reflect its original ties to France. The canton of the flag had a single yellow star on a field of red to show its early origins with Spain. At this time, Louisiana troops were among the best equipped and uniformed in the Confederacy. There was as yet no standardization within the Confederate army, and so there were as many blue-coated Confederates in Louisiana as gray-clad ones. Some regiments had as many as ten different uniforms.

On the extreme left, a first lieutenant of Louisiana Zouaves chats with his

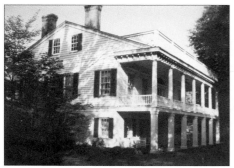 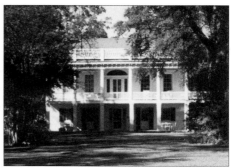

These photographs served as the guide for my depiction of Arlington Plantation in *Moonlight and Magnolias* and *Magnolia Morning.*

wife. At this point, the war had not yet begun, and conventional wisdom propounded that—if war came—the South was assured a quick victory and continued status as a new nation with all the glory, pomp, and honor that accompanied such achievements.

The next couple, to the right of the flower arrangement resting on the column, shows a former U.S. naval commander in full dress uniform. He has resigned his commission and awaits assignment to the Louisiana or Confederate navy. He and his wife, in the golden dress, are the only ones at the party who spot the stolen kiss and smile knowingly.

In the center, with the woman in the violet dress, is a first lieutenant of Confederate marines, a corps that received little recognition during the war. Farther to the right, we see a sergeant of the Washington Artillery, from New Orleans, chatting with his wife and their three children.

The party setting gave me a rare chance to depict a bit of antebellum life with an excellent opportunity to show many types of uniforms that caused so much confusion in the early months of the war. The lighting effects and the beautifully attired men and women make for a sparkling array of glamour and pageantry. That would all change when the war came and ground on for four years toward its inevitable conclusion of destruction and grief. One year after this party, New Orleans would be an occupied city, and two years later, Ulysses S. Grant would come down the Mississippi and spend two months trying to cut a canal from the river to Lake Providence in order to gain access to the Red River. This would have allowed the Union army to reenter the Mississippi River south of Vicksburg. Among Grant's officers who would use Arlington Plantation as their headquarters were James B. MacPherson, James W. McMillan, and John MacArthur. Grant would visit the house as well. Needless to say, life at Arlington Plantation would never be the same.

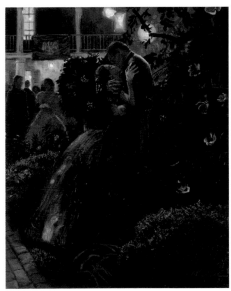

STOLEN KISS

STUDY

1997, oil, 20 x 16

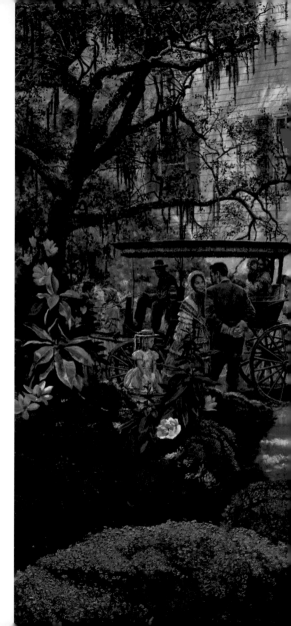

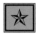

MAGNOLIA MORNING

ARLINGTON PLANTATION
LAKE PROVIDENCE, LOUISIANA
APRIL 7, 1861

2001, oil, 26 x 36

THIS COMPANION painting to *Moonlight and Magnolias* depicts the morning of great dreams and high hopes that followed the gala ball that celebrated the South's new nationhood and honored the men in gray who would be going to war. As the soft morning light bathed a new day, it was time for good-byes.

Now, the young men in their new uniforms shared farewells with loved ones. It was a bittersweet moment. Departure was difficult, but ahead awaited glory, honor, and the fortunes of war. Such scenes were enacted across the country—in both the

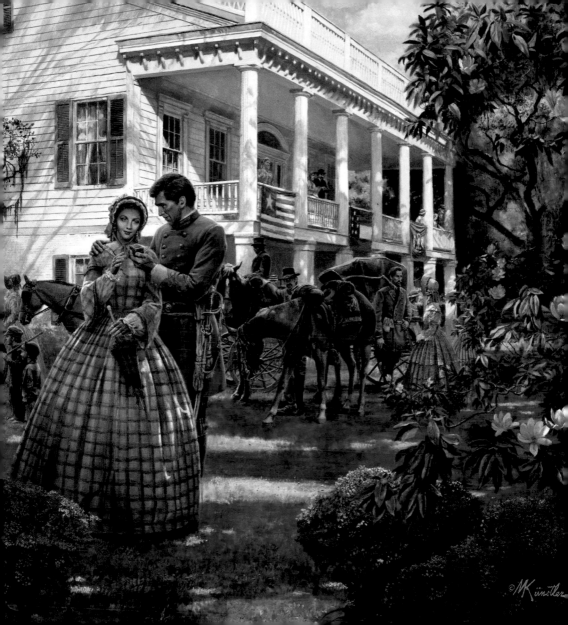

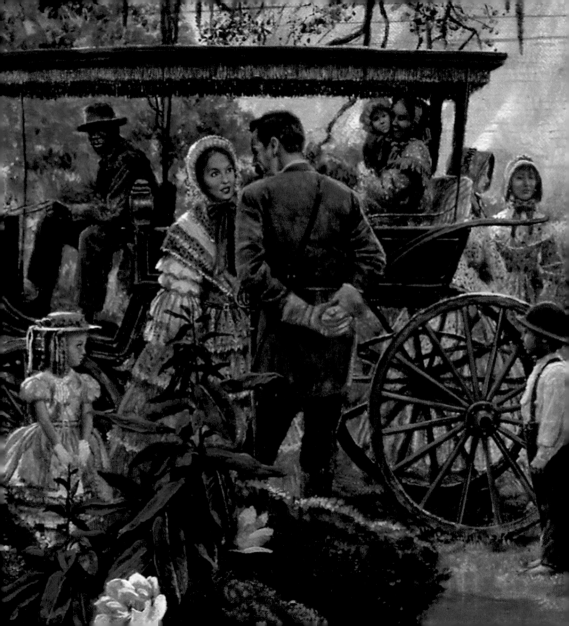

North and the South. Very soon, however, the romance of the moment would pass.

For the present, however, Americans basked in a patriotic glow. The young men of the North were preparing to fight for the Union. Southerners were rushing to arms to defend their homeland. The balls and celebrations were over; ahead lay the ravages of war. Yet in the fleeting softness of a new day and the gentle squeeze of a tender embrace, there was a brief shining moment that would be remembered always.

The day after the *Moonlight and Magnolias* ball provided a wonderful scene. In contrast to the moonlight of the first picture, I painted bright sunlight. The guests are leaving Arlington Plantation, so their carriages are seen waiting. The women are fashionably attired in their day dresses, just as they were properly dressed in their beautiful gowns the night before. The men are wearing their new uniforms and preparing to join their units. The same flags that were displayed at the ball—Louisiana flags and the Confederate first national flag—are still hanging from the upstairs railing of the plantation house. I purposely placed the house at a different angle, and it, of course, looks magnificent from any point of view.

By combining the blooming azaleas and magnolias, the bright sunlight and the blue sky with puffy white clouds, I tried to capture the optimistic feelings of that day. I chose to emphasize the theme of hopes and partings by including a presentation of a going-away gift as the central focus of the image.

Of course, reality would set in soon—the white clouds would symbolically become the dark clouds of war—and life at Arlington Plantation would become a test of wartime endurance.

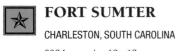

FORT SUMTER

CHARLESTON, SOUTH CAROLINA

2004, gouache, 12 x 12

ONE OF the many crises in the months between the election of Abraham Lincoln and his inauguration was centered in Charleston, South Carolina. In December 1860, the Federal garrison there abandoned its mainland fort for a more tenable position in the harbor at Fort Sumter. But in doing so, the military situation only worsened, and Confederate Gen. P. G. T. Beauregard (formerly superintendent of the U.S. Military Academy at West Point) oversaw the erection of gun batteries north and south of the Union fort in concert with the guns of Forts Moultrie and Johnson. Demands that all Federal property be surrendered to the newly constituted republic of South Carolina were refused.

War came at 4:30 a.m. on April 12, 1861, when Beauregard's gunners opened fire on the harbor fort. The general estimated he had sufficient powder and ammunition for a forty-eight-hour shelling, but only if the shelling was methodically timed. He ordered that each gun be fired in a counterclockwise circle around the fort, with two minutes between each shot.

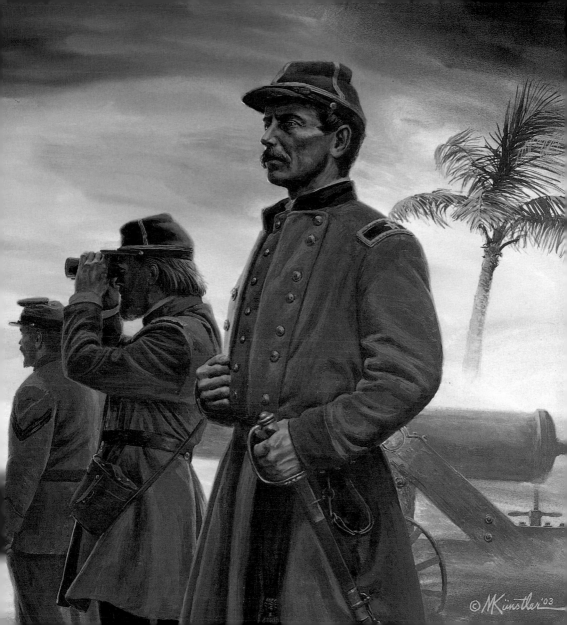

THE FLAG AND THE UNION IMPERILED

SGT. JOHN CARMODY, FORT SUMTER,
CHARLESTON HARBOR, SOUTH CAROLINA, APRIL 13, 1861

1978, oil, 16⅛ x 18

THE SMALL Union garrison at Fort Sumter was outnumbered and outgunned. Confederates fired four thousand shells in a thirty-four-hour period. With limited powder at hand, the Federal commander, Maj. Robert Anderson, ordered his gunners to concentrate their fire on the batteries shelling the fort and to avoid targets in the city. At the end of the first day, the Union guns ceased fire, and Confederate gunners slowed their fire.

By dawn of April 13, several fires burned within the fort, cloaking the bastion in smoke. To avoid asphyxiation, Anderson ordered his men to the lowest level of the fort and only occasionally fired in reply to the shelling.

Sgt. John Carmody was one of the few who defied Anderson's orders and returned to the guns on the upper tiers of the fort. The heavy guns on the top tier were ready for firing. Although six to eight men were normally required to handle these guns, Carmody alone fired each gun as he moved from one to the next, all down the line.

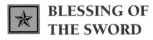

BLESSING OF THE SWORD

2002, oil, 14¼ x 23⅜

THIS SCENE was repeated across the country during the opening weeks of the war. In the North and the South, responsible men responded to the call from their states and left home and family to take up arms. Leave-takings could be as brief and simple as an embrace and a promise to return. Among the gentry, departures were often marked with a solemn ceremony. Family and friends gathered to support the one who was bound for

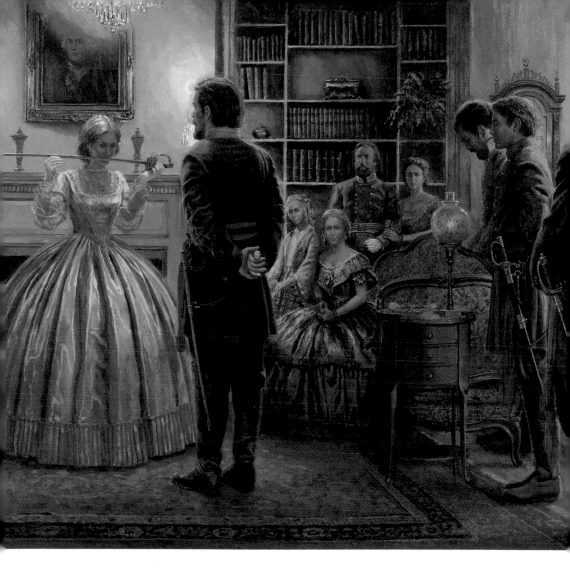

war. Endearments were shared, memories were recalled, toasts were offered, and prayers for protection were offered.

Often such ceremonies climaxed with the presentation of an ornately engraved sword. It was offered with a heartfelt blessing, a benediction of hope that the sword would never be unsheathed or that it would protect its bearer from the brutality of battle. It was typically received with gratitude and a vow to carry it with honor, to faithfully do one's duty, to return when the homeland no longer needed defending, and even in the darkest hour, to remember those left behind.

I was inspired to undertake this work by Thomas B. Read's poem "The Brave at Home."

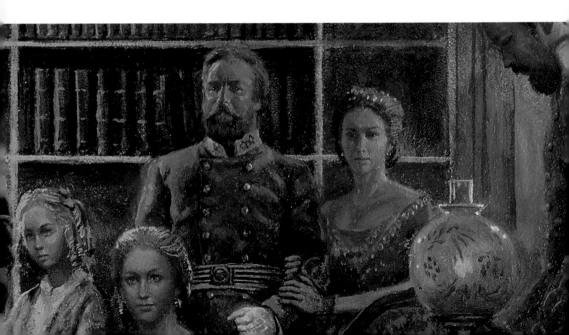

The wife who girds her husband's sword
'Mid little ones who weep or wonder,
And bravely speaks the cheering word,
Even though her heart be rent asunder,
Doomed nightly in her dreams to hear
The bolts of death around him rattle,
Has shed as sacred blood as e'er
Was poured upon the field of battle.

In my research, I learned that these presentation swords and sabers were usually handsomely crafted, nonregulation weapons given as a token of esteem by family, friends, or admirers. Sometimes, when the gift was very expensive and the recipient was very popular, funds for its purchase were raised by subscription in the community.

Presentation ceremonies were often formal and elaborate, but sometimes they were an intimate family affair set in a drawing room with relatives and close friends. I chose the latter for my setting because it gave me an opportunity to paint a poignant scene that was common during the war, and this setting allowed me to portray an interior scene with dramatic lighting. It also allowed me to portray clothing styles and furnishings typical of the country's leading families during the era. I can only imagine the words that were said by a wife or sweetheart like this Southern woman before lifting the blade to her lips and what emotions touched the hearts of the loved ones who were present. These tender farewell moments reflected our forebears' devotion to both family and duty.

THE PROFESSOR FROM VIRGINIA

THOMAS J. JACKSON
VIRGINIA MILITARY INSTITUTE

2002, oil, 11 x 9¼

THOMAS J. JACKSON was a professor of physics (known then as natural and experimental philosophy) and artillery at the Virginia Military Institute in Lexington when the war began. A member of the West Point class of 1846, he had served in the Mexican War and emerged from that conflict with the brevet rank of major. In 1851, at the age of twenty-seven, Jackson left the army for the classroom, even though he had no formal teaching experience and knew very little about "natural philosophy."

Jackson was no great success in the classroom. He memorized his lectures the day before delivering them and recited them accordingly. The Major (as he came to be known in Lexington) fared better on the parade ground and in instructing young gunners.

In late November 1859, Jackson commanded the cadet artillery that traveled to Charlestown, Virginia, under orders from the governor "to preserve the peace and dignity of the commonwealth in the execution of John Brown."

Wykoff

nd plane

bolic curves

VIRGINIA

©M Künstler '02

THE ROAD TO GLORY

MAJ. THOMAS J. JACKSON LEAVES VMI
APRIL 21, 1861

1997, oil, 18 x 34

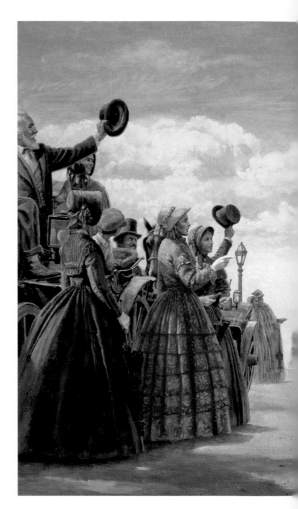

AS SOON as Virginia withdrew from the Union on April 17, the superintendent of VMI, Col. Francis H. Smith, offered all the academy's resources to the state. In the meantime, all academic activities were suspended, and the cadets drilled.

Jackson was not a secessionist, but as a faculty member at a school institution, he knew where his loyalties must be. All of his time was then spent either at VMI or preparing to depart on short notice. When the sun

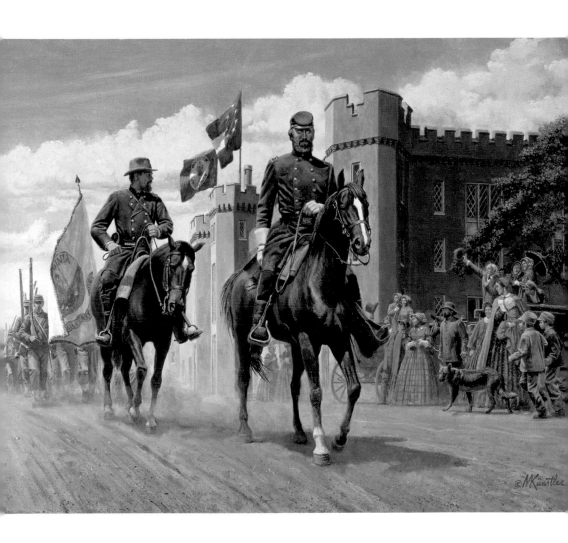

rose on Sunday, April 21, orders arrived at Jackson's home that he would be leading the cadet corps (minus forty-seven) to Richmond to act as drill instructors for the assembling army. Departure was set at 12:30 p.m.

After several hours of preparation, Jackson went home for the last time. He returned to VMI shortly before noon. The wagons were ready, and 176 cadets and eight officers were awaiting Jackson's order to move out.

The Jackson who commanded this group was not the same man who had been viewed as a bungling professor. Maj. Raleigh Colston, a fellow VMI professor, observed a change in Jackson's deportment: "His speech quickened, his eyes glittered, his drowsy manner had left him, and his whole nature seemed to wake up."

At the appointed hour, Jackson mounted his horse and called the cadets to attention followed by, "Right face! By the file left, march!" And the four companies marched to the rhythm of a drum and fife down the hill on which their school was perched.

To research the painting, I met with Professor James I. Robertson Jr., the foremost authority on Jackson, and Col. Keith Gibson of the VMI Museum. Together we traced the actions of Jackson and the cadets by walking the same route at the same time of day. I settled on this specific spot for a number of reasons. I wanted to depict the main barracks as a principal element in the painting because of the angle and the lighting effect the sun would create at midday. By taking a low eye level, I was able to silhouette Jackson's head against the sky, adding clouds behind his head to create an even greater contrast for the dark of his hat and beard.

Major Colston follows Jackson, and the white VMI flag—the same as is

THOMAS J. JACKSON LEAVES VMI

LEXINGTON, VA., APRIL 21, 1861

1995, mixed media, 17 x 20½

used today—leads the cadets. The Virginia state flag and the first national flag of the Confederacy fly above the barracks building. It was an exciting day for the community, and the townspeople turned out to cheer their sons in a show of support.

In the background, the famous statue of Washington by Jean-Antoine Houdon bears silent witness to the beginning of the tragic drama of the war.

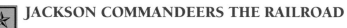

JACKSON COMMANDEERS THE RAILROAD

MARTINSBURG, VIRGINIA, JUNE 1861 — 1999, oil, 22 x 48

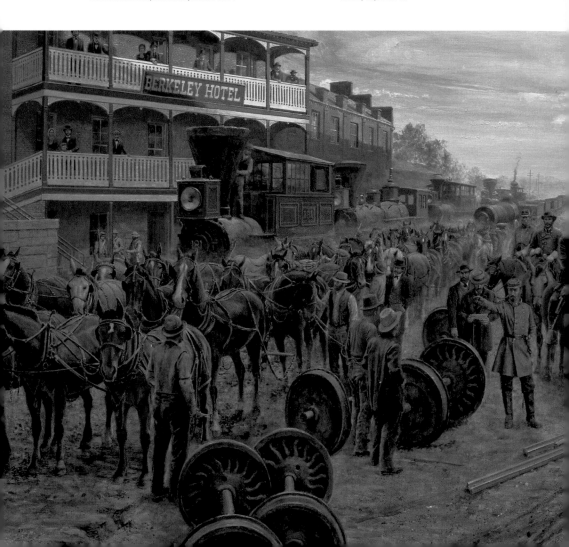

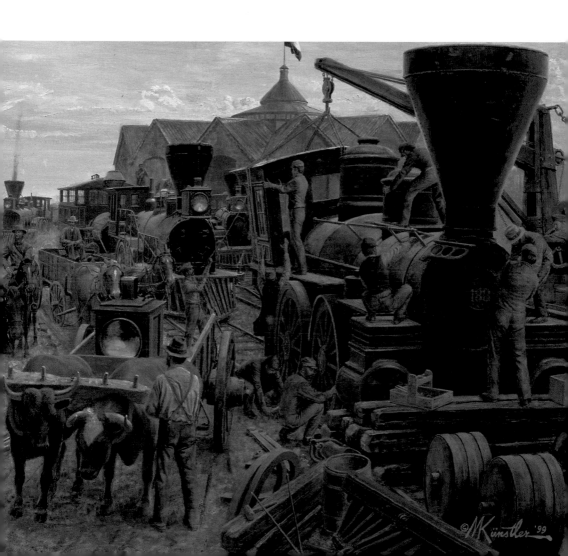

During the many years I have been painting Civil War scenes, I have never had more requests to paint an event than this one. The overland hauling of locomotives and other rolling stock from Martinsburg to Strasburg, a distance of thirty-eight miles, was one of the most difficult and daring feats of the war. Likewise this is one of the most difficult and daring paintings I have ever done. It was a complicated subject with an enormous amount of details that required tremendous research.

Federal forces advancing from Williamsport, Maryland, were approaching Martinsburg, Virginia, trapping railroad equipment that could no longer be utilized by the Confederates. To prevent the enemy from using the complex of railroad resources in the area, Gen. Thomas J. Jackson received orders to destroy the railroad workshops at Martinsburg. He followed orders but also conceived a plan to move the rolling stock and equipment overland and into Confederate hands. Railroad experts Hugh Longust and Capt. Thomas R. Sharp arrived from Richmond and selected thirteen of the least damaged locomotives.

The task of hauling these behemoths overland was enormous, especially after factoring in the condition of the roads and the weight of the locomotives. Crews of teamsters, mechanics, and laborers were assembled. Herds of horses were brought into town. To lighten the load, mechanics dismantled the engines as much as possible, removing bells, whistles, pistons, cow catchers, stacks, and cabs. The tenders were detached. The front truck wheels were replaced with improvised extra-wide wooden wheels. The front driver wheels were removed. The rear drivers had to be widened, and the

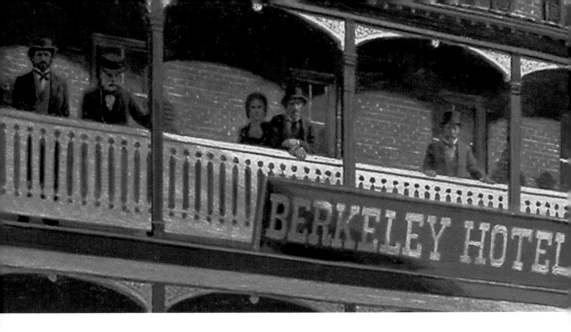

effect of the flange had to be eliminated, which was accomplished by adding wide wooden wheels with iron banding.

Teams of forty horses were hitched together—including mules, thoroughbreds, and workhorses—and all sorts of harnesses were improvised. The feat of maneuvering turns and grades on the macadamized surface of the valley pike must have been an incredible spectacle. Each trip required three days of hard labor.

At Strasburg, the parts were placed aboard trains and shipped to Richmond, where they were reassembled and resumed the work for which they had been designed. The success of this operation established a model for the overland shipping of rolling stock, and the practice originated with Jackson.

In the painting, Jackson is the center of attention. He still wears the blue VMI instructors' uniform and sits on horseback, viewing the path the forty-horse team will take. Captain Sharp points out the route. I was able to view Jackson's coat and kepi at the VMI Museum with the kind cooperation of Col. Keith Gibson. Accompanying Jackson are his mounted staff members—2nd Lt. Sandie Pendleton, in the red kepi, and Dr. Hunter McGuire, both seen to the left of Jackson, and Maj. John Harmon, seen to the right of Jackson. Once again, Professor James I. Robertson Jr. of Virginia Tech assisted me with the crucial details.

It is early in the morning of June 20, 1861. The sun starts to catch the higher parts of the roundhouse and the Berkeley Hotel. The city of Martinsburg

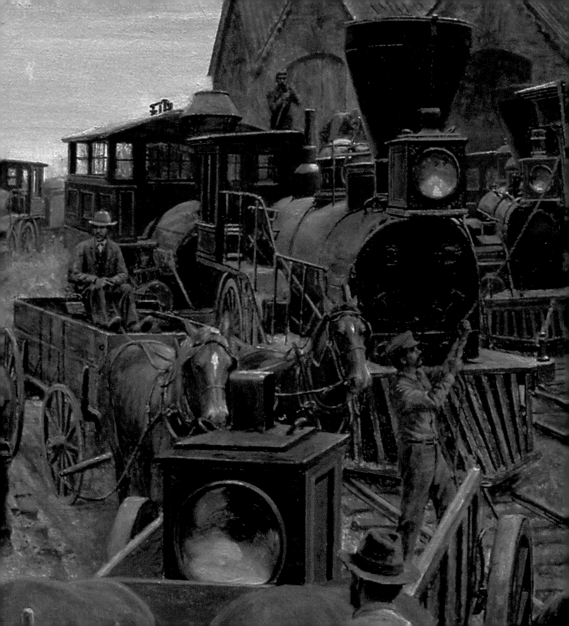

recently restored the hotel to its nineteenth-century condition, with minor changes. It is used today as an Amtrak Station. I painted it the way it was during the war with the Berkeley Hotel sign on the building.

President of the Martinsburg Historical Society, Don Wood, was extremely helpful in answering questions for me. We walked the tracks together in Martinsburg until I could find the exact spot where I could capture all the excitement and the hotel and roundhouse in a single scene.

I visited the B&O Railroad Museum in Baltimore where executive director Courtney Wilson graciously supplied all sorts of information and photographs pertaining to the roundhouse and trains, including the types of locomotives and the correct numbers and colors of the engines that were in Martinsburg at the time. Curatorial assistant Harold Dorsey also helped to answer my numerous questions. Information on the manner and means of disassembly was obtained from Chris Ahrens, supervisory exhibit specialist at Steamtown National Historic Site in Scranton, Pennsylvania.

The last piece of information I needed regarded the forty-horse hitch. We were able to track down Paul Sparrow of Zearing, Iowa, who's the only person in America capable of driving a forty-horse hitch. His information was invaluable.

Although this is the most difficult Civil War painting I have ever done, it is also one of my great favorites. I am thankful I had the opportunity to record and preserve this remarkable historical event. It inspired me to do another painting—the next painting in this volume—as a companion piece and shows the team in action through the streets of Winchester.

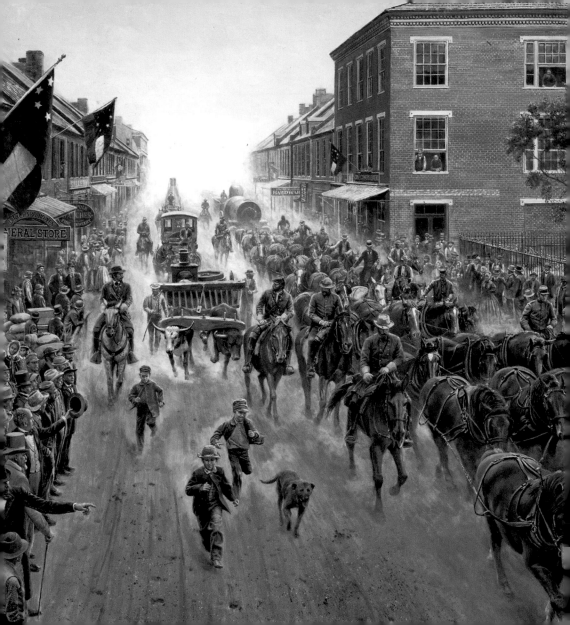

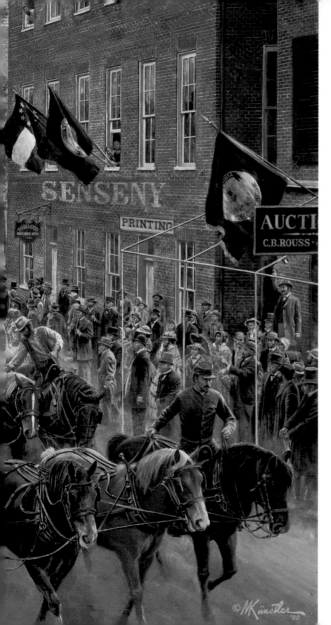

 IRON HORSES, MEN OF STEEL

WINCHESTER, VIRGINIA
JUNE 1861
2000, oil, 28 x 40

BEFORE I had completed the painting *Jackson Commandeers the Railroad* in 1999, I knew I wanted to do a sequel showing another part of the operation. This great event of moving locomotives and railroad equipment overland and through towns had never been depicted and would be a natural follow-up to the scene showing the dismantling of the locomotives in the Martinsburg railroad yards.

In my research for the previous painting, I learned about

the disassembling of the locomotives and how they were moved. Winchester, Virginia, was the natural choice for me as the setting for this painting since it was the largest town between Martinsburg and Strasburg, where the locomotives were shipped to Richmond and put back on the tracks. Since Loudoun Street has been featured in my paintings *Jackson Enters Winchester* and *After the Snow,* I wanted to portray the locomotive scene in a way that would not be reminiscent of the other two. I decided to use a high perspective so the viewer could see down the entire street. This presented a new set of problems that, in the beginning, seemed almost insurmountable. Using this perspective meant that I had to gather additional information on what buildings were in Winchester during the war, what they looked like, and who occupied them. Added to this was the magnitude of the event that required me to portray crowds of people that would have turned out to witness the spectacle.

The forty-horse teams used to pull the stripped-down boilers were rigged four abreast and driven, artillery style, by riders who controlled four horses each. Since thoroughbreds, quarter horses, mules, and other beasts were conscripted for the arduous movement, some owners refused to part with their mounts unless they drove them personally. The result was a joint military-civilian operation. Artillery riders with their distinctive red markings are in key positions in the lineup as outriders available for troubleshooting. The rest of the equipment—cowcatchers, lights, cabs, and stacks—were transported by wagons and oxcarts.

Looking north, on the left side of the street in the distant background, is the columned three-story Taylor Hotel, the featured building in my first painting of Loudoun Street, *Jackson Enters Winchester.*

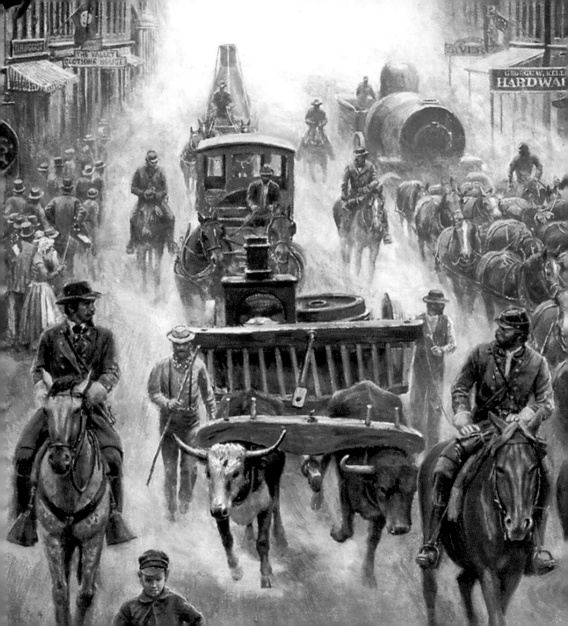

On the extreme right side of the painting is a building that was an auction house run by C. B. Rouss. The building no longer exists and has been replaced with a parking lot. But the Senseny Building, just to the north, still stands. It has been fully restored and is now known as the Feltner Building and houses the Feltner Community Foundation Museum. The open area with the tree and iron fence around it is the courtyard in front of the Winchester Courthouse that was featured in my other Loudoun Street painting, *After the Snow*.

Going farther back on the right side of the street is Rouss Avenue, known as Railroad Avenue during the war. It is the narrow street on the other side of the fence between the courtyard and the three-story Taylor Confectionery and Bakery. Taylor's was torn down and replaced in 1902 by the F&M Bank, a build-

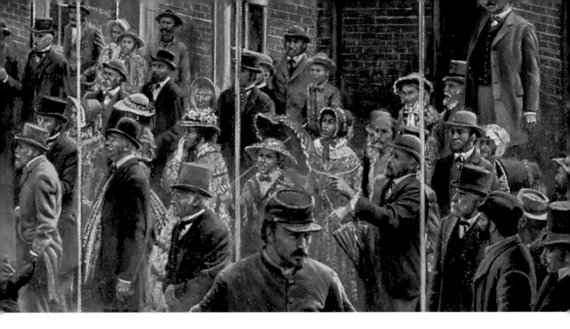

ing that still stands today. Loudoun Street, once know as the Old Valley Pike, is today a main street featuring a beautiful walking mall with many of the buildings seen in this painting still intact. All of the names on the signs and the locations of the various businesses are as accurate as could be ascertained and would not have been possible without the help of Ben Ritter, the most knowledgeable historian of Civil War Winchester.

I hope that this painting captures an event of epic accomplishment and helps to instill a spirit of learning from the past and to inspire preserving what we have in the present for future generations.

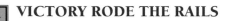

VICTORY RODE THE RAILS

JACKSON AT PIEDMONT STATION, JULY 19, 1861

2005, oil, 20 x 40

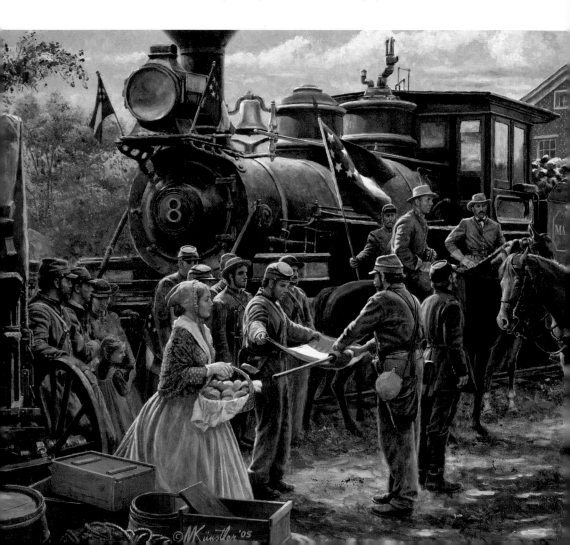

GOING TO war seemed like a grand holiday. Throughout North and South in the summer of 1861, young men gleefully donned new uniforms, shouldered "rifle-muskets," and cheerfully marched off from home and family. Northerners boasted that they would whip the Rebs in ninety days. Southerners claimed that one of them could lick ten Yankees. It all seemed like a Sir Walter Scott adventure, only real. Not yet, but soon, this unrealistic, romantic notion would be shattered for countless young men, many of whom would never see home again.

But some knew the terror that lay ahead. Brig. Gen. Thomas J. Jackson, an unremarkable mathematics instructor at the Virginia Military Institute, was a Mexican War veteran, and he did all he could to prepare his troops—Virginia's First Brigade—for the reality of war.

When word came that a Federal army of thirty-three thousand untrained citizen-soldiers was marching on Manassas Junction and P. G. T. Beauregard's twenty-two thousand raw recruits, Confederate Gen. Joseph E. Johnston's eleven thousand were summoned. Among Johnston's command near Winchester was Jackson's twenty-six hundred men.

Fifty-seven miles separated them from the battlefield, but they would only have to march twenty-three miles. Arrangements were being made at Piedmont Station for trains to transport the troops the last thirty-four miles.

After a day's wearisome march, Jackson's troops arrived at Piedmont Station around 8 a.m. While they waited for the trains, a picnic atmosphere prevailed. As they boarded a train—marking them as some of the first troops

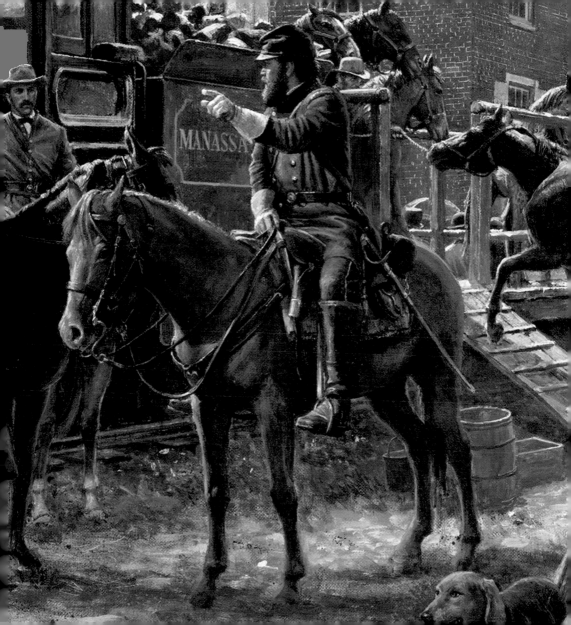

moved to battle by rail—they encountered a boisterous celebration. Flags were flying, troops were waving, and young women were passing out treats. A holiday atmosphere masked a grim reality: many of these youngsters, like their Northern counterparts, would soon be dead or wounded in the war's first major battle at First Manassas. There, too, near the banks of an obscure creek known as Bull Run, the unremarkable VMI professor would rally the shaken Southerners, help turn the day for the Confederacy, and emerge forever famous as Stonewall Jackson.

Ideas for my paintings come from different sources, and *Victory Rode the Rails* is no exception. The name was inspired by the title of a 1953 book by George Edgar Turner. I was en route to an appearance at Shenandoah Univer-

sity when I encountered the historic site that led me to paint this scene. Bill Austin, director of the university's History and Tourism Center, had met me at the airport in Washington, D.C. As we passed near the town of Delaplane, he said he wanted to show me something interesting. We crossed some railroad tracks and stopped in front of an old brick building, now housing an antiques store. During the Civil War, he told me, the structure was the railroad station for the town, which was called Piedmont Station at that time. It was here, I learned, that Jackson and his troops boarded a train that would take them to the battle of First Manassas and everlasting fame.

What a great subject for a painting! The scene had never been painted, and I could include a building that still exists today—which I always enjoy. I

consulted with Professor James I. Robertson Jr., author of the acclaimed biography *Stonewall Jackson,* and with a very knowledgeable railroad historian, Courtney Wilson, executive director of the B&O Railroad Museum in Baltimore. As usual, I also studied a variety of historical works related to the subject. The more I learned, the more I wanted to paint this picture!

In the center of interest, Jackson sits on Little Sorrel, giving orders to his aide, Lt. Col. Sandie Pendleton, who is accompanied by Jackson's chief surgeon, Dr. Hunter McGuire. Jackson, of course, still wears his blue VMI uniform. The Piedmont sign is clearly visible, and the tender of the locomotive bears the name of the Manassas Gap Railroad on its side. Overcrowding

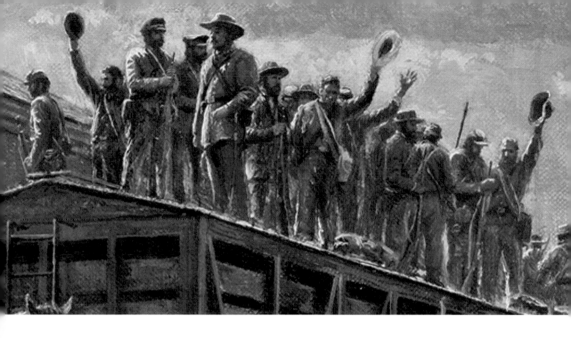

forced a large number of troops to ride atop the train cars next to where the brigade's horses are being loaded. Everything shown in the painting is supported by primary sources—eyewitness accounts, diaries, official records, and memoirs. It's quite poignant when you think about what awaited these young men at Manassas. Also, here is Jackson—just another officer in a prewar blue uniform—on the verge of becoming the famous Stonewall. To me, it was an extraordinary event that begged to be recorded—an absorbing, colorful expression of our American heritage.

The thirty-four-mile trip took eight hours. Storm clouds gathered when they disembarked. The storm would last almost four years.

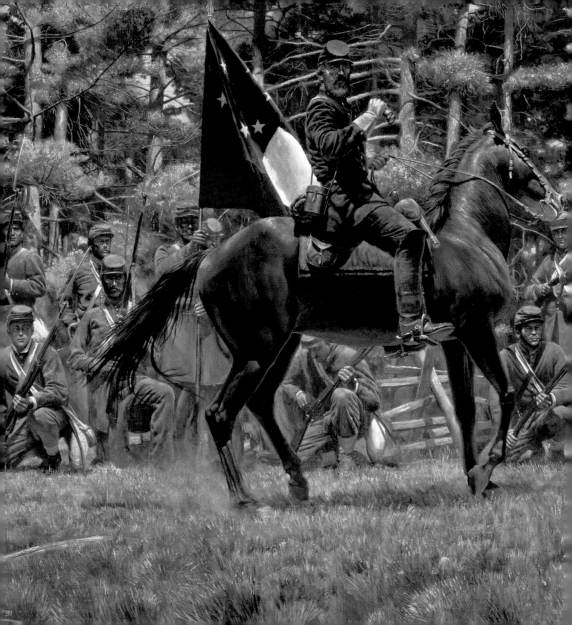

"THERE STANDS JACKSON LIKE A STONE WALL"

GEN. THOMAS J. JACKSON AT FIRST
MANASSAS, JULY 21, 1861

1991, oil, 24 x 36

ON A hot summer afternoon, in the first major battle of the Civil War, Thomas J. Jackson earned one of the most famous nicknames in military history.

His brigade had arrived on the scene late on Friday afternoon, July 19, and awaited orders while the remainder of Joseph E. Johnston's army from the Shenandoah Valley moved to join it. P. G. T. Beauregard wanted to attack Irvin McDowell's Union army, but Johnston argued for a defensive approach. Both armies viewed the

71

other's left flank as its target. McDowell probed Beauregard's and Johnston's line until he found an undefended crossing of the creek known locally as Bull Run. On Sunday morning, July 21, he attacked, preempting Beauregard. In response, the Confederate commander shifted brigades recklessly before he realized the weight of the Union attack was focused on his own left flank.

Three regiments bore the brunt of the assault while other units moved to support them. On his own initiative, Jackson brought his regiments into the area around 11 a.m. They emerged from the woods onto the east side of Henry Hill into a mass of shocked and panicked troops fleeing from the enemy. Jackson detained a three-gun section from abandoning the area, then he calmly rode toward the crest of the hill and surveyed the fighting. He could have rushed his troops into the battle or provided support for a withdrawal. He chose instead to establish and stabilize a line behind the hill, out of sight from the Federals.

Jackson spent roughly an hour deploying his men. His flanks were protected by woods to the left and a creek to the right. Six more guns arrived to bolster the artillery at hand. And Beauregard and Johnston visited the hill around noon and saw that Jackson had matters under control. All realized the strategic significance of the line he had devised.

For more than two and a half hours, Jackson's men waited and endured a shelling from twenty-four Union guns. There were casualties, but rather than panic, the Virginians eyed their commander slowly riding back and forth along the line, periodically and methodically calling out, "Steady, men, steady! All's well!"

When the front ranks of the original three regiments finally broke and fled

up and down Henry Hill, they crossed in front of Jackson's line and moved to the right flank to re-form. Union troops were not far behind.

One of the regimental commanders, Barnard E. Bee, was on horseback and rode to the line, inquiring as to what command this was and being directed to Jackson. The two men talked briefly after Bee offered a quick report on the action. Emboldened by Jackson, Bee returned to his regiment and said: "Look, men, there is Jackson standing like a stone wall! Let us determine to die here, and we will conquer!"

In that moment, the legend was born.

Jackson's line held that day, and before the sun set, the Federal army retreated in panic. They left the field to the Confederates, and among them was a new hero of the South whose genius was just beginning.

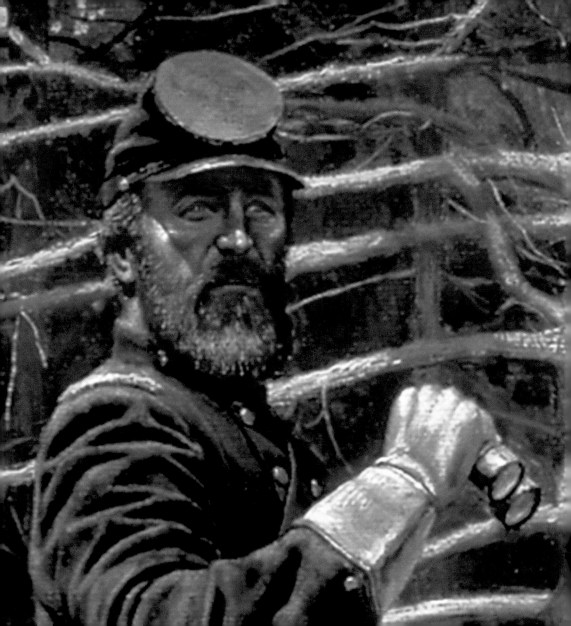

I went to the Manassas battlefield to see how I could accurately and directly tell this story. When I saw the pine woods down the slope from the Henry house from which the hill received its name, where Jackson had formed his line, I immediately knew it would make a perfect backdrop for the picture. It gave me an opportunity to do a painting unlike any I had done before.

Jackson, of course, is the center of interest. He is dressed in his old blue VMI uniform and forage cap and looking attentively to the crest of the Henry Hill in the west, waiting to catch the first glimpse of the Union troops.

The flag is the first national flag of the Confederacy, and it is easy to see why there was so much confusion during the early stages of the war because of its similarity to the Stars and Stripes. Added to this were the blue uniforms of many of the Confederate officers from the prewar army. This, of course, would change with time.

Behind Jackson is his gray line of Virginia infantry, many in the early frock coat of the Virginia militia that was later abandoned. Headgear was predominantly kepis and forage caps, which would give way to the much more popular slouch hat. All were armed with Model 1842 muskets. Bayonets have been fixed, and the glint of the midafternoon sun must have been an awesome sight for the Federals who were soon to rush headlong into a fight they believed was almost over.

This moment was truly the calm before the storm.

"THE SWEETEST MUSIC..."

GEN. STONEWALL JACKSON,
NOVEMBER 4, 1861

1995, mixed media, 18½ x 24¾

Iɴ ᴛʜᴇ fall of 1861, the Confederate army was reorganized, and Jackson was appointed to command the Shenandoah Valley military district of the Department of Northern Virginia. To do so, he had to relinquish command of the Stonewall Brigade. On November 4, he received orders to report to Winchester. After some private good-byes to his officers, he rode to a field where the brigade stood at attention. Jackson addressed them with a quivering voice, recalling all that they had accomplished together. Then he rode away, tears welling in many eyes, to a deafening cheer that followed him all the way to the valley.

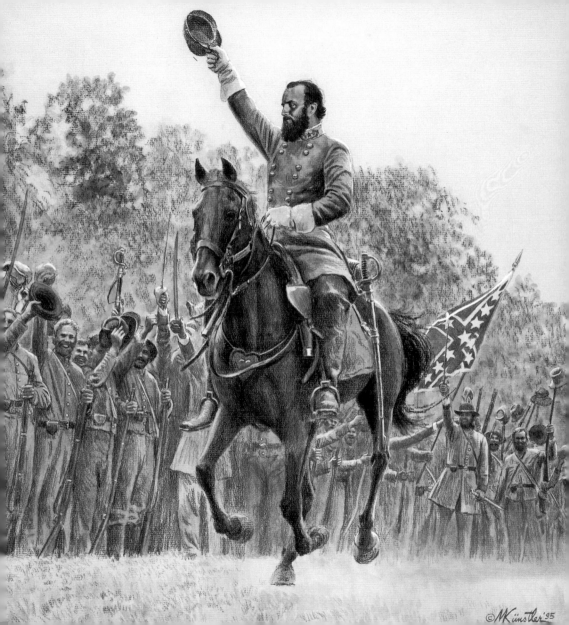

FIRST TO THE GUNS

BATTLE OF WILSON'S CREEK, MISSOURI,
AUGUST 10, 1861

1992, oil, 18 x 30

detail, right

THE BATTLE of Wilson's Creek was second only to Manassas as the bloodiest engagement of the first year of the war. Casualty rates were higher here than those around Bull Run, but the clash was far removed from the capitals of the North and the South, and thus attracted less attention.

Union efforts in Missouri, led by Gen. Nathaniel Lyon, had been highly aggressive and very successful in the early months of the war. But the Southerners received reinforcements from Arkansas, and on August 10, two armies faced each other near Springfield in the prairie around Wilson's Creek. Lyon was killed in the fighting, and the Confederates advanced to the Missouri River. By the end of the year, however, the Union army had regained control of the state. Afterward Missouri guerrillas harassed Federals in actions that left the state bleeding long after the war was over.

In *First to the Guns,* I wanted to capture the pivotal moment of the battle of Wilson's Creek: Col. James McIntosh's capture of the last Union battery in the field. He leads the Third Louisiana, known by its distinctive pelican flag, and the Second Arkansas Mounted Rifles.

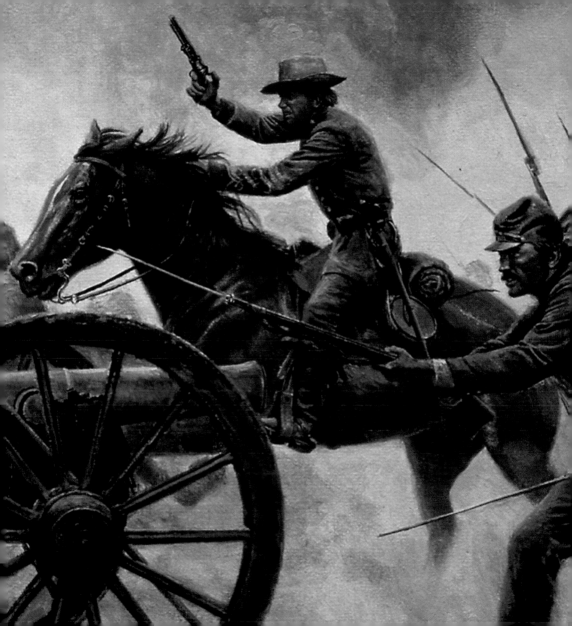

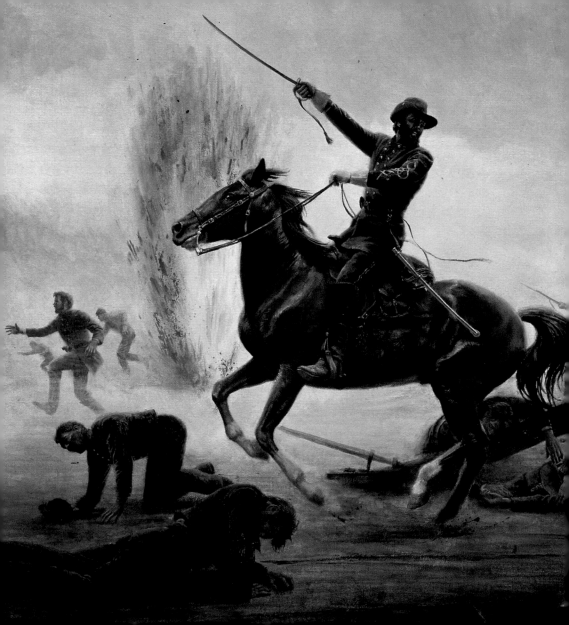

CHARLESTON— AUTUMN 1861

GEN. ROBERT E. LEE AT THE MILLS HOUSE

1997, oil, 24 x 38

detail, right

FOR SOUTHERNERS, the fall of 1861 was a season of great expectations. Eleven states had formed a new nation—the Confederate States of America—and the fledgling country had successfully defended itself in the field. The large-scale battles that would produce America's bloodiest war had yet to occur. And so Southerners were still rushing to arms, fielding new troops, parading through city streets, and drilling on courthouse squares.

Nowhere did the flame of Southern patriotism burn brighter than in Charleston, South Carolina. Like most Americans on both sides, Charlestonians believed the war would be brief and bloodless. The Federal naval blockade had not yet applied its deadly squeeze. Union artillery had yet to bombard the handsome city structures into battered ruins. The pain and suffering of war had not yet reached most Southern homes.

Instead, an atmosphere of hope and celebration intoxicated the South— and Charleston. Companies like the Jackson Guards—named for martyr James T. Jackson—paraded through Charleston's streets before admiring onlookers. Southern women made uniforms and raised funds for the boys in the field. Southern dignitaries were honored with receptions and grand balls.

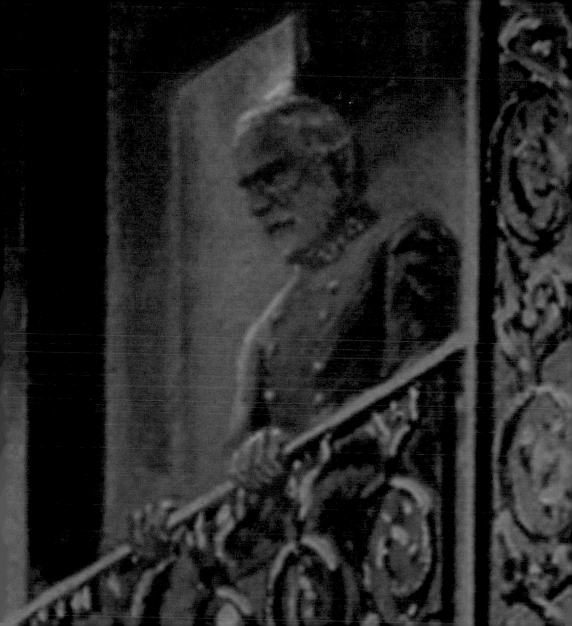

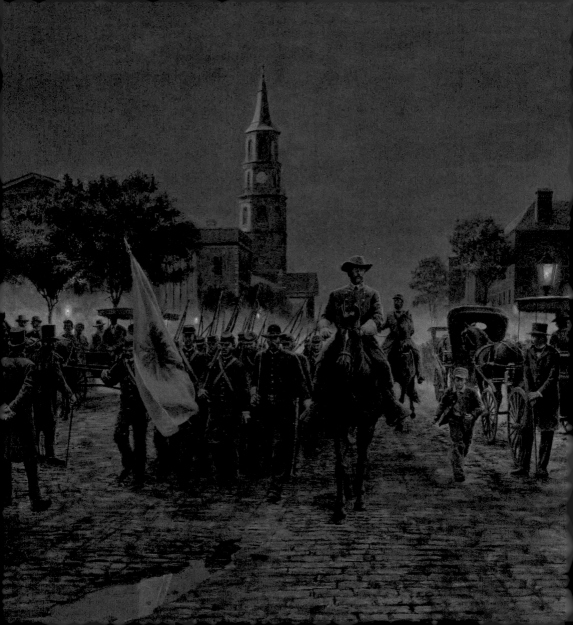

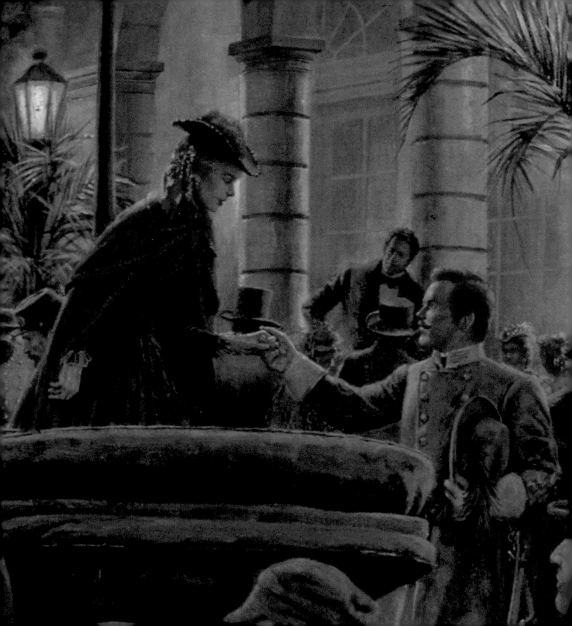

In mid-November 1861, Gen. Robert E. Lee was welcomed to Charleston by the city's leading citizens. As special military adviser to President Jefferson Davis, Lee had come to oversee development of South Carolina's coastal defenses. He was a guest at the Mills House, Charleston's most prestigious hotel, and was treated as a most honored visitor. Rank and position—not fame—afforded him these genteel courtesies. He was not yet the South's most beloved figure; that glory lay ahead of him. Such acclaim—and the wartime horrors to come—could hardly be imagined amid sea breezes on a warm autumnal night in Charleston.

Today, the Mills House has been rebuilt and restored to its original splendor. When I learned of Lee's visit to Charleston in 1861, I immediately knew what I wanted to paint. Research confirmed Lee's stay and revealed what troops were in the city that day.

In this painting, I have portrayed the Mills House and several other buildings that were there then and still exist today. Hibernian Hall (the Greek Revival building up the street from the Mills House) and the wonderfully restored St. Michael's Church (on the opposite side of Meeting Street) are visible in this painting.

On this evening, begowned women and uniformed officers arrive for a reception in Lee's honor. State troops march beneath their distinctive flag. They attract Lee's attention as well as that of several young boys and older men who wish they were the right age to serve the cause. This was before the bloody fighting of 1862, when the real horrors of war began. Instead, in November 1861, a spirit of gallant patriotism dominated the day. Pageantry and parades were common, and the future of the South looked bright and promising.

GUNS OF AUTUMN

LEE IN CHARLESTON

2000, oil, 26 x 36

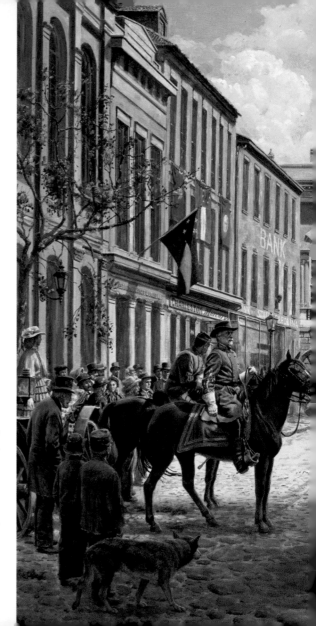

Throughout their new nation, Southerners prepared for war. Gone were the hopes for a quick and bloodless victory. Gone too were thoughts of invincibility. Instead, they hurriedly strengthened their defenses. Still, in most places this autumn, the guns were silent as both sides mustered resources for the coming storm.

In the autumn of 1861, Robert E. Lee was in command of the Department of South Carolina, Georgia, and Florida, with his headquarters in Charleston. A gifted engineer, Lee devised a defensive strategy, organized resources, and directed

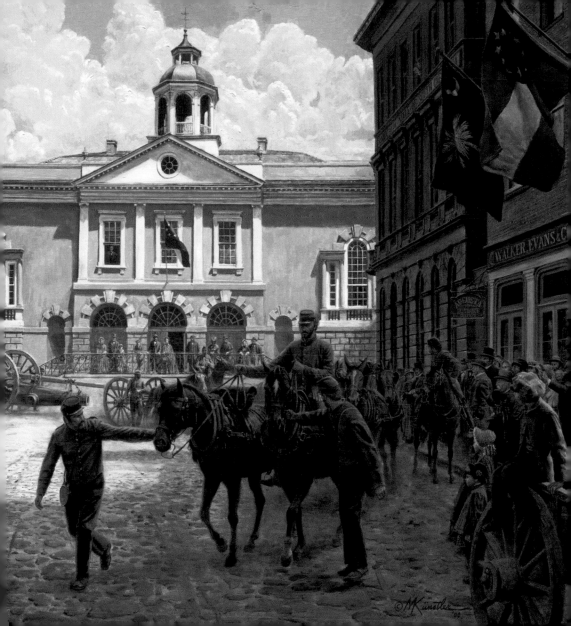

deployments of troops and artillery. His efforts would prove to be crucially important, and his defenses would endure for most of the war..

In this painting, I wanted to address the two areas of the war that had been virtually ignored by other artists. One is Lee's assignment to the Carolinas; the other is the role of heavy artillery on the coastline. I decided to combine these two elements in one painting and give both the recognition they deserved.

The proper setting was, of course, Charleston. I chose to paint a view from Broad Street, looking east. This gave me an opportunity to look head on at what is now known as the Old Exchange; it was the city's post office during the war. The cupola has been changed three times and looks slightly different from its antebellum days. After a 1981 restoration, the Old Exchange appears

today very much as it did during the war. Frances McCarthy, director of the Old Exchange, was of enormous help with this research.

From Charleston history expert Jack Thomson I learned that on the left (north) side of the street on the corner was the Bank of South Carolina. Next to it was the office of the *Charleston Mercury*. The South Carolina state flag, the first national flag of the Confederacy, and the Virginia state flag (in honor of Lee) hang outside the newspaper office. While these two buildings have been replaced, the third building from the corner remains in such good condition today that you can still see the stone-carved lettering of the Charleston Insurance and Trust Co. The building on the extreme left also exists, as do the three buildings on the right side of the street. The signs accurately indicate the businesses that were there during the war. This type of cobblestone street can still be seen in parts of Charleston, but it has been replaced on Broad Street.

For information about transporting heavy artillery I consulted Warren Ripley's *Artillery and Ammunition of the Civil War*. Talley Kirkland, a National Park Service historian at Fort Pulaski National Monument, provided expert advice on a variety of important points. In the painting, we see an 8-inch seacoast Columbiad being transported on a specially designed cart. The cart had enormous wheels and was hitched to a caisson pulled by a team of twelve horses and mules. The details of the hitch and the operation of such a difficult maneuver were checked by Col. David Stanley, an artillery expert.

To me, the war's opening days are so interesting to paint. The uniforms are bright and colorful, and the civilians are cheerful and optimistic. Sunshine, blue skies, and puffy white clouds reflect this mood before it gives way to the realities of war—tattered uniforms, hunger, gloom, and hardship.

THE WINDS OF WINTER

JACKSON'S ROMNEY CAMPAIGN,
JANUARY 1862

2000, oil, 24 x 36

IT WAS nothing like their early dreams of war. Federal forces had invaded the Shenandoah Valley, and an army of Southern soldiers had been dispatched to protect their homeland. Their objective was the Shenandoah Valley hamlet of Romney, where the Union army was encamped—but the Valley weather, not the Yankees, proved to be the fiercest enemy. Less than a year earlier, these sons of the South had rushed to arms, filled with romantic notions of gallantry and glory. Now they faced the cold, bitter reality of life in the field.

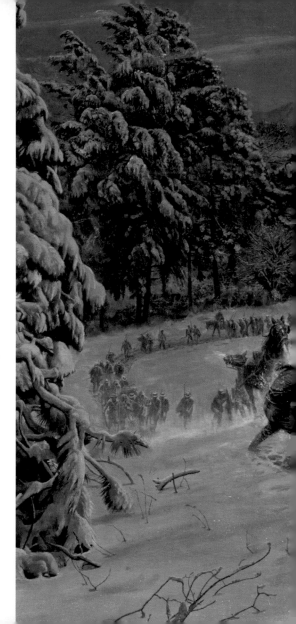

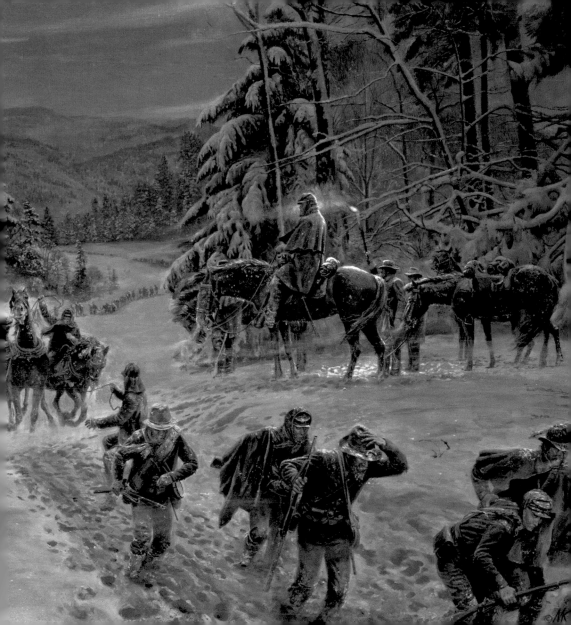

Jackson issued orders for the march on New Year's Eve. The march was to begin at 3 a.m. on January 1, but it was 9 a.m. before the march began. It was an inauspicious start to Jackson's first offensive since taking command of the Shenandoah Valley military district. His force consisted of four brigades; three of them were for the first time under his command. Five artillery batteries and a small militia brigade completed the assembly.

There was no consensus regarding the distance or the speed with which the men would progress over uneven ground toward their target. Supply wagons lagged far behind, and columns became ensnarled. Progress was slow. While spirits were high as the march began, a sudden change in the weather made everything worse. Deep snow and bitterly cold temperatures quickly transformed the march into a grueling ordeal.

Reported one Confederate officer: "The road was almost an uninterrupted sheet of ice, rendering it almost impossible for man or beast to travel, while by moonlight the beards of the men, matted with ice, glistened like crystals." Recalled another, "If a man had told me 12 months ago that men could stand such hardships, I would have called him a fool."

Despite the almost unbearable conditions, they persevered—led by a relentless warrior: Thomas J. "Stonewall" Jackson. Determined to do his duty and rid the Shenandoah Valley of the invaders, Jackson drove his troops forward day and night through the snow, wind, and ice. Soon, as if awed by Jackson's sheer willpower as much as the savage weather, the Federals retreated without doing battle. Left behind was a horde of supplies and weapons to be confiscated by the jubilant Confederates. Months ahead, in the spring and summer to come, greater glory awaited: Jackson's brilliant, victo-

rious Valley campaign. It too would be won with the same determination and endurance that had enabled Jackson and his "foot cavalry" to win the winter war.

A great source of inspiration for my paintings has been the work of Professor James I. Robertson Jr. His biography *Stonewall Jackson: The Man, The Soldier, The Legend* offers a vivid description of Jackson's winter expedition from Winchester to Romney, West Virginia, and was the primary inspiration for *The Winds of Winter.*

The campaign began on January 1, 1862, on a deceptively springlike day. Many of the inexperienced soldiers chose to leave behind their overcoats. That afternoon, a northwest wind began to blow, and temperatures soon

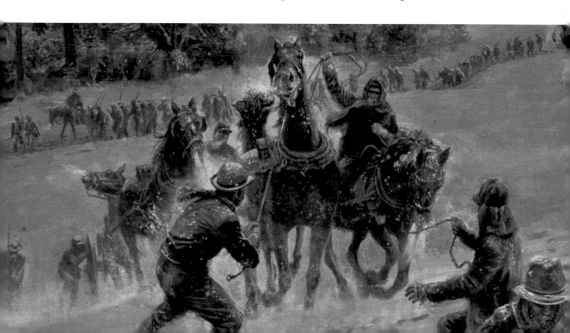

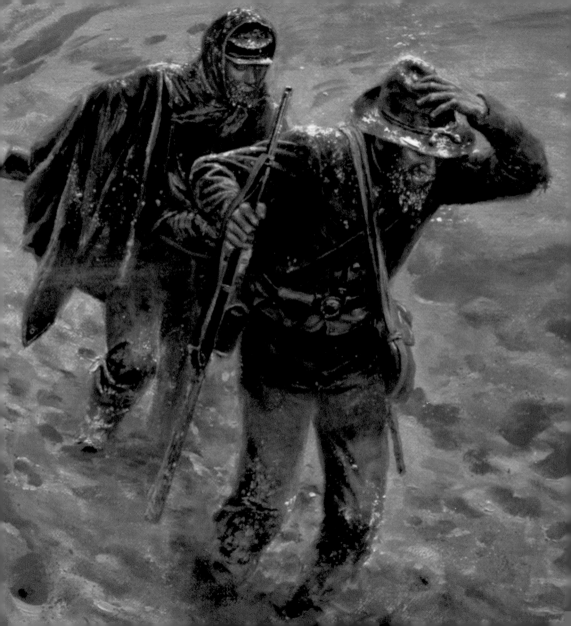

plummeted. The men's hardships increased with the bitter cold. They suffered from lack of food, inadequate clothing, and poor shelter. Over the course of the two-week march, the troops experienced the most arduous conditions imaginable, including almost impassable roads, freezing temperatures, and unrelenting snow, wind, sleet, and rain. The horses also struggled. "Icicles of blood hung from the horses," noted Robertson in his biography.

Jackson directed the grueling march with all the fervor and devotion of an Old Testament–style warrior. By the sheer force of his willpower and personality, he was able to drive men to do what many considered impossible. The torch held by one of Jackson's aides shows the army strung out across the wintry landscape and confirms that they have far to go before they can bivouac.

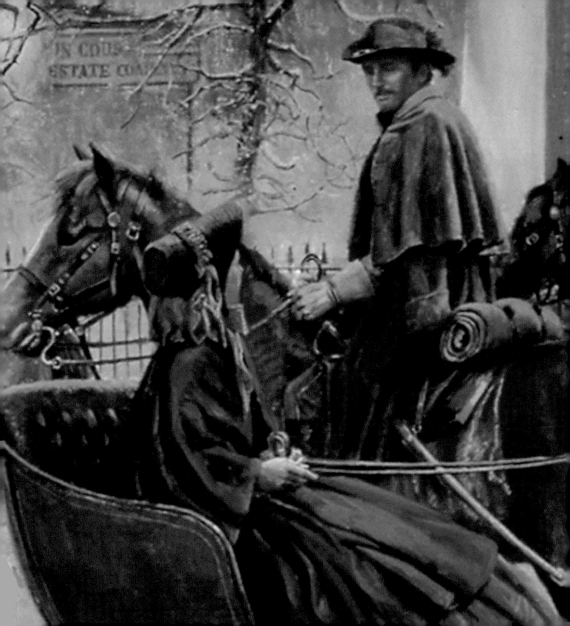

AFTER THE SNOW

WINCHESTER, VIRGINIA
JANUARY 6, 1862

1998, oil, 26 x 48

detail, left

IT WAS a brief interlude of peace and security amid the long winter of war. Situated at a critical point on the North-South invasion route through the Shenandoah Valley, historic Winchester, Virginia, was repeatedly occupied by invading armies. Happily for the residents of the town, the new year of 1862 found the area in Confederate control. Under the protection of friendly forces, Winchester's citizens could strive to make the days of war as normal and tolerable as possible. Bedecked by a mantle of fresh snow, the courthouse looked much as

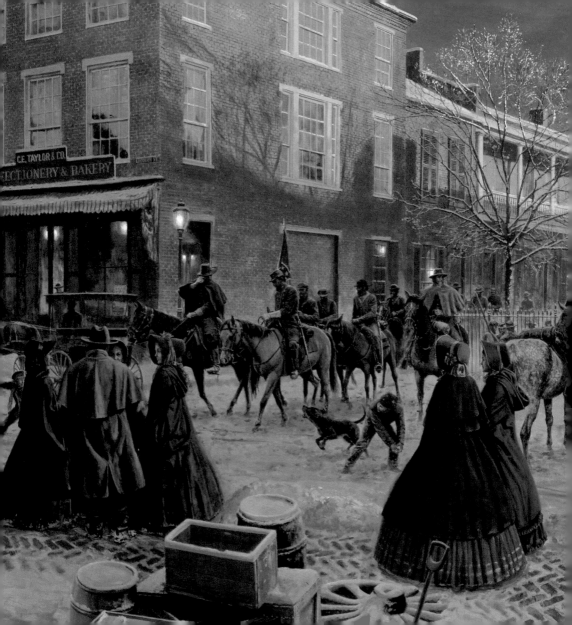

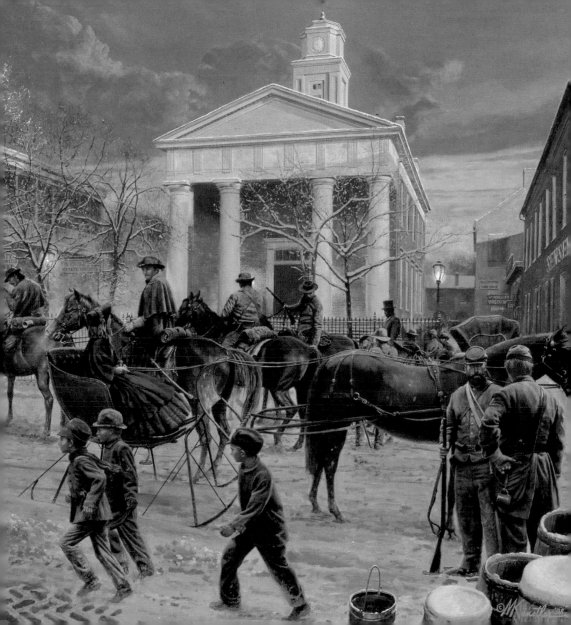

it did in the days of prewar peace. Children were free to romp in the snow. Women could gather comfortably outside Loudoun Street's shops. Passing troops, however, were a subtle reminder that this season of peace and goodwill was fragile and fleeting.

Winchester's wartime tranquility would end in the spring, when Union Gen. Nathaniel P. Banks's troops would occupy the lower Shenandoah Valley. Although Banks's army would be vanquished by Jackson's army at the first battle of Winchester, the Federals would return. Bloody battles would be fought at Winchester again in 1863 and 1864. Always, the invading armies returned. Finally, in mid-1864, Union Gen. Philip Sheridan's cavalry laid waste to much of the Valley. It was a devastating campaign, so brutal that for generations it was simply referred to as "the Burning."

But in early January 1862, the cruelest wages of war were unimaginable in the South. Winchester residents, like most Southerners, still held high hopes for an early peace and a happy homecoming for their sons.

For years I had wanted to paint the Winchester courthouse. Its fenced-in area was used by both sides to confine prisoners, and with the town constantly changing hands, the courthouse was in frequent use. By painting the scene in winter (when the courtyard was not a prison), I could focus on the courthouse and incorporate some of the other buildings in the area.

The 1840 courthouse has changed little since the Civil War. But the only pictorial evidence I had was James E. Taylor's drawings in *Traveling with Sheridan Up the Valley*. He depicts the courthouse in two sketches that are informative but also problematic. In both drawings, a fan-shaped window appears within the triangular facade under the roof and above the columns.

There is no evidence of that window today. I was certain that no artist would take time to paint in a window unless it was actually there. But Winchester historian Ben Ritter believed that Taylor had confused the buildings when he returned to his studio to execute his final drawings; Taylor had made similar mistakes in other drawings and paintings based on his notes and sketches. Architectural historian Maral Kalbian pointed out that fan-shaped windows were more appropriate for a Jeffersonian Roman Revival–style rather than the Greek Revival–style of the courthouse. And the town clerk's office examined the courthouse and confirmed there was no evidence of a fan-shaped window. So I omitted that feature so prominent in the Taylor sketches.

The C. E. Taylor & Co. (no relation) Bakery is on the left where the F&M Bank stands today. The building on the extreme right was the Senseny Building during the war. It is now the Feltner Building, which houses the Feltner Community Foundation Museum. To the right of the courthouse in the far background, with the arches, is the Market House. Behind the Senseny Building are the clerk's office and the office of the *Winchester Virginian.*

According to Professor James I. Robertson Jr., on January 6, 1862, Winchester had a four-inch snowfall. The time of the painting is 4:50 p.m., about fifteen minutes before sunset, and as a storm passes to the northeast, the sun has just popped out before setting. Sadly, the storm clouds of war would not go away so easily.

A FLEETING MOMENT

STONEWALL AND MARY ANNA JACKSON,
WINCHESTER, VIRGINIA, FEBRUARY 1, 1862

2003, oil, 26 x 38

detail, right

Gen. Thomas J. Jackson—the mighty Stonewall—pondered most of his strategy privately. Ardently concerned about security, he spoke little of his plans to anyone until he began to unleash them in hammerlike strikes against the enemy. To ensure success, he constantly oversaw preparations in person. He rode his lines on horseback, checked on his troops, and mentally rehearsed his plans and options to perfection.

Even so, his thoughts were often with his wife. Mary Anna Morrison Jackson, a minister's daughter, shared an extraordinary love with her husband that was founded and flourished on a shared faith in God.

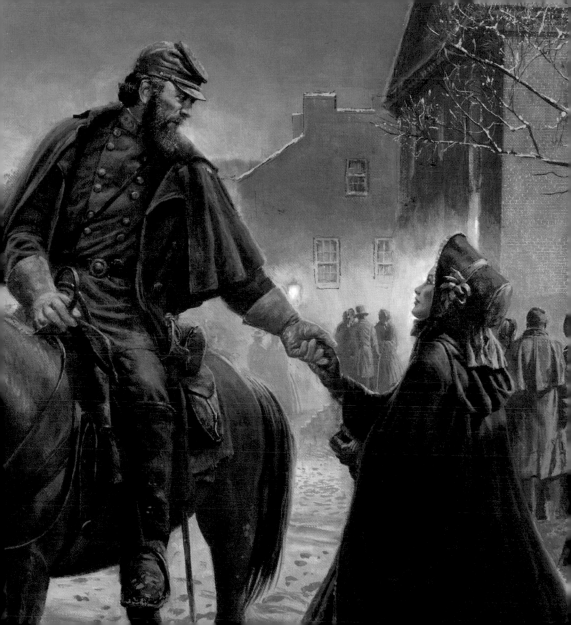

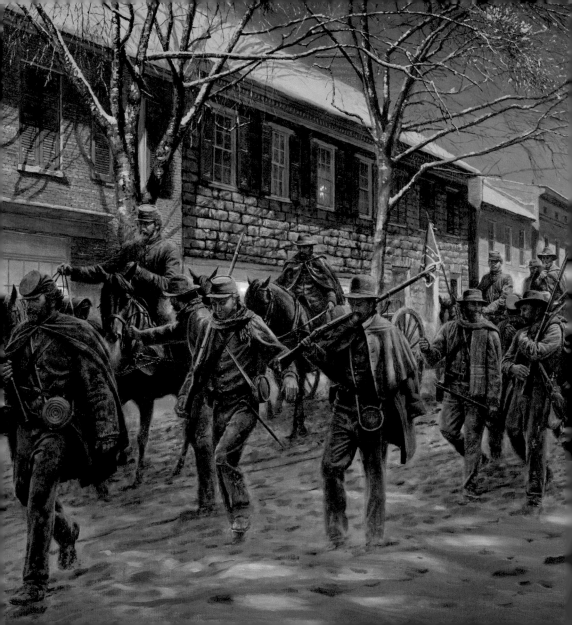

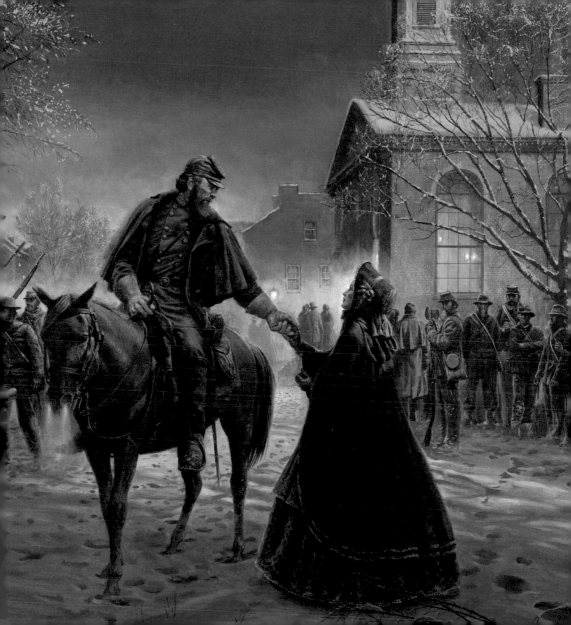

In the winter of 1861–62, Mary Anna left their Lexington, Virginia, home and joined Jackson at his Winchester headquarters, from where he conducted his famed Valley campaign. As he routinely moved about his army, leaving nothing unchecked, he had ample opportunity to spend time with his beloved *esposita*. Without question, the interlude in Winchester brought Jackson some of his dearest moments of the war. In early 1862, more accomplishments, more fame, more glory awaited him.

Still, Jackson savored the blessings of his relationship with his beloved wife. To the end, Thomas and Mary Anna Jackson would be bound by a deep

and abiding commitment—a commitment shaped by the biblical love that "never fails."

I can't count how many times since I painted *Until We Meet Again* that I have been asked to paint another version of the Jacksons in a tender moment. I had believed it would be very difficult to equal or top one of my most popular paintings, and I approached the task carefully and with great trepidation. Finally, time and opportunity allowed me to address such a scene.

I chose Winchester again as the setting—both for historical and artistic reasons. The general and his wife had little time together during the war, and their time here was the single longest interlude they enjoyed. She left Winchester bearing their daughter, Julia.

This painting is situated on Loudoun Street, highlighted by the Loudoun Street Presbyterian Church. The church is still standing today, but its appearance has changed radically since the war. Dedicated in 1841, the current facade and steeple were erected in 1883. The steeple replaced the cupola seen in the painting. I felt it was the perfect setting for Jackson and Mary Anna. The church and the street were familiar to both of them. They worshiped at the church that winter, and Jackson passed that way many times on his official duties. All the buildings in this latest painting are still standing except for a few in the background. This view of Loudoun Street can still be enjoyed on the walking mall in Old Historic Winchester.

I hope the painting reflects the special relationship that existed between the general and his wife, which, of course, did much to contribute to the remarkable man we all know today as Stonewall Jackson.

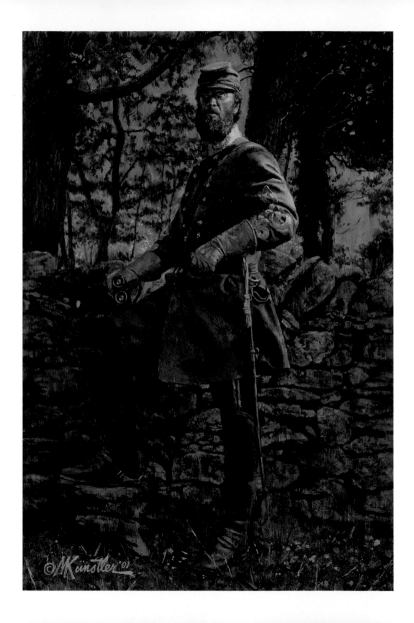

STONE WALL

GEN. THOMAS J. JACKSON

2001, oil, 11⅜ x 7⅜

THE THOMAS JACKSON who commanded the Shenandoah Valley military district of the Department of Northern Virginia was not the same Thomas Jackson who had recited his lectures in the classrooms of the Virginia Military Institute less than a year ago. Although they shared many of the same characteristics—reticence, shyness, awkward at conversation, and clumsy around others—Jackson the commander was someone to fear, someone who persevered with an inexhaustible relentlessness. He still followed the same monastic diet, but he was constantly active and no longer performed the strange physical exercises that had led others to label him as a "town character" in Lexington. As a teacher, his unyielding demands on his students elicited nicknames such as "Tom Fool" and "Old Blue Light." Whereas one cadet believed Jackson was "the worst teacher that God ever made," another dismissed him as being "crazy as damnation." Now he was known both North and South as Stonewall. His name terrified his opponents and thrilled his countrymen. And the soldiers in the ranks, when he wasn't driving them as his "foot cavalry," cheered him whenever they saw him.

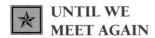

UNTIL WE MEET AGAIN

JACKSON'S HEADQUARTERS,
WINCHESTER, VIRGINIA, WINTER 1862

1990, oil, 30 x 46

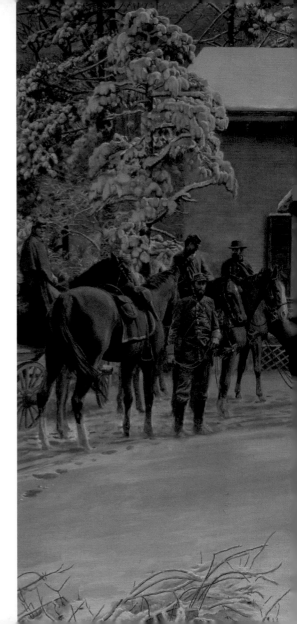

THE INSPIRATION and idea for this painting came about through a series of circumstances. The Farmers and Merchants Bank of Winchester had purchased my original painting *Jackson Enters Winchester.* The chief executive officer of the bank, Wil Feltner, asked me if I would be interested in doing a companion piece. Of course, I was.

During a visit to Stonewall Jackson's headquarters in Winchester, I learned that the historic building had never been depicted in a painting and decided this would be a perfect opportunity to do so.

112

No fighting had taken place at Jackson's winter headquarters, so I chose to illustrate a tranquil snow scene. In walking around the former Lewis T. Moore house, I found that the most interesting side of the building was the original front. Aside from the entrance, the only major changes made since Jackson's time were the addition of two dormers on the second floor.

It was here in Winchester that Mary Anna, Jackson's second wife, joined him for the winter of 1861–62. They stayed at the home of Dr. James R. Graham, just a few doors away from the Moore house. Mary Anna would often walk to Jackson's headquarters with a basket of food for supper.

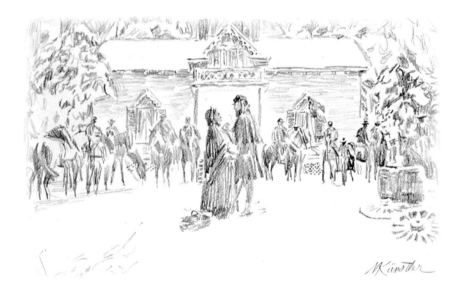

The scene shows Jackson saying good-bye to Mary Anna. His blue uniform is worth noting. The coat is the same one he wore at the Virginia Military Institute. It conforms to the 1850 Uniform Regulations for Virginia Militia and, except for the buttons, is the "Old Army" uniform. Confederate Gray had not yet become universally standard.

As his entourage waits, the Jacksons walk a few steps away for some parting words in private. Staff members witness this tender moment. Maj. Henry Kyd Douglas, the mounted officer on the extreme left of the painting, would later gain fame as a Jackson biographer. On foot and immediately to the right of Douglas is Lt. Col. William Allan, Jackson's chief of artillery. Directly behind him, a mounted trooper chats with Capt. Jed Hotchkiss, topographical engineer and noted mapmaker.

To the left of the stairs is Hunter McGuire, Jackson's medical chief, who later was to make his home in Winchester. Alongside McGuire in the red artillery officer's kepi is Lt. Sandie Pendleton. On the right of the stairs, the Reverend Maj. Robert L. Dabney, in winter cape and coat, waits with Capt. J. G. Morrison. To the right of Morrison, a mounted trooper carries the standard of the first national flag. Maj. D. B. Bridgford is on the extreme right. The rest of the officers and men wait patiently for their commander, some turning away to allow the general this unexpected show of tenderness.

The Jacksons' only child, Julia, was born the following November.

I was privileged in 1989 to meet Julia's daughter, Mrs. Julia Christian Preston, the granddaughter of Thomas and Mary Anna Jackson. At the age of 103, she was attractive, bright, alert, and well and living in North Carolina.

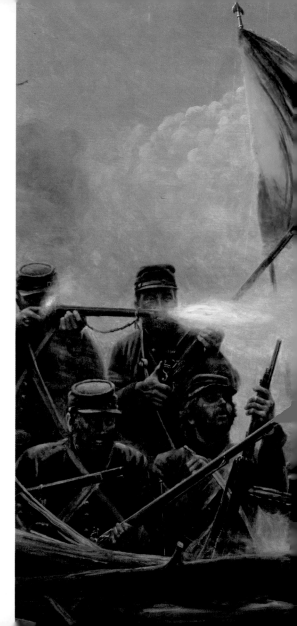

 REBEL SONS OF ERIN

FORT DONELSON CAMPAIGN,
FEBRUARY 13, 1862

1996, oil, 22 x 36

MY FIRST painting of an Irish regiment—*Raise the Colors and Follow Me!*—was done in 1989 for the U.S. Army War College. It was my introduction to the major contributions made by Irish Americans to both sides during the war. Most students of the war are familiar with the role of Irish troops in the Union army, but less is known about Irish Confederates.

One of the most fascinating Irish regiments in the war was the Confederate Tenth Tennessee, which I

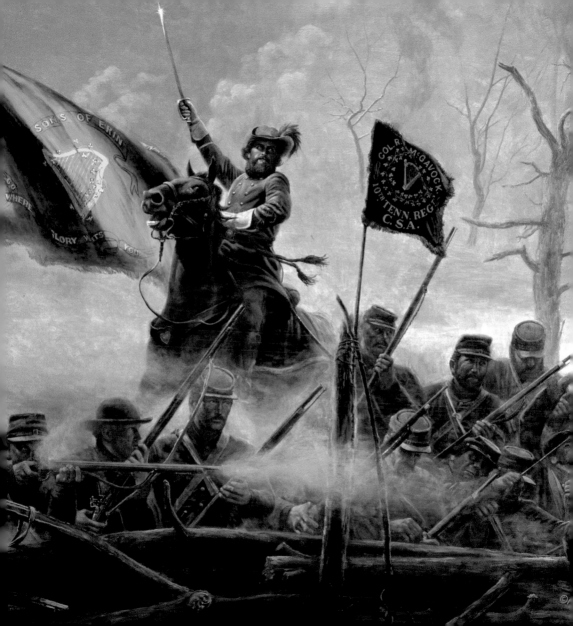

learned about while reading a biography of Nathan Bedford Forrest. The regiment is fully profiled in Ed Gleeson's regimental history, *The Rebel Sons of Erin*. Gleeson and his work have been most helpful to me in researching this painting, so I named it after his book as a tribute to him.

Other historians also gave me valuable advice. Thomas Cartwright, the historian at the Carter House in Franklin, Tennessee, uncovered important information and a rare photograph of the regiment's Pvt. Patrick Griffin. Sheila Morris Green, an assistant curator at the Tennessee State Museum, consulted with me about the regiment's original flag and the personal banner of Lt. Col. Randal W. McGavock—both of which are held in the museum's collection. McGavock's banner is in the foreground of the painting, and the regimental flag—which was huge!—dominates the center of the picture. Robert Wallace of Fort Donelson National Military Park was also helpful in confirming details.

The regiment at this time was furnished with new uniforms by McGavock, a former mayor of Nashville. The uniforms were carefully described by Pvt. Jimmy Doyle in his diary, which has been preserved. Although the Tenth Tennessee was considered one of the best-equipped regiments in the war's western theater, its troops were armed at this time with flintlock muskets from the War of 1812.

The moment depicted is the engagement at Erin Hollow, which occurred on February 13, 1862, during the Fort Donelson campaign. It was the only time the full regiment engaged in battle as a complete unit. But I wanted to capture more than a dramatic moment by highlighting the Irish who fought as bravely for the South as they did for the North.

THE GHOST COLUMN

COL. NATHAN BEDFORD FORREST,
FORT DONELSON, TENNESSEE,
FEBRUARY 16, 1862

1991, oil, 22 x 30

DURING ONE of my searches for the snow scenes that I like to do each year, I found a story that intrigued me while reading *First with the Most* by Robert S. Henry.

Late in the evening of February 16, 1862, in a council of war at Confederate Fort Donelson, the commanders decided that it would be fruitless to continue their resistance against the superior forces of Union Gen. Ulysses S. Grant. A then unknown lieutenant colonel of cavalry, Nathan

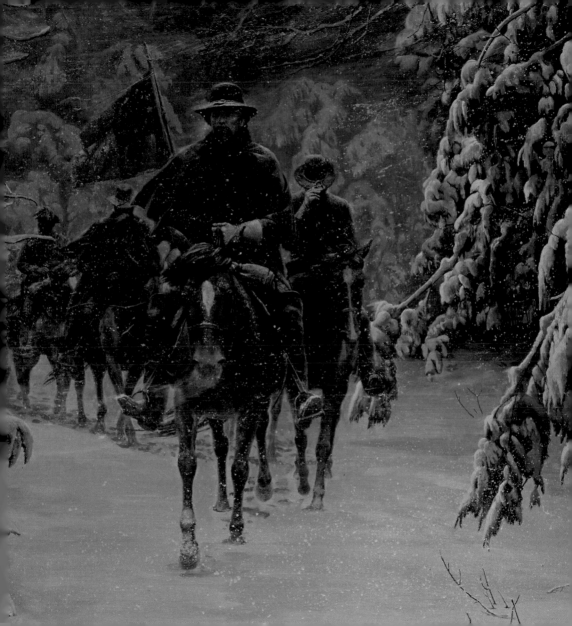

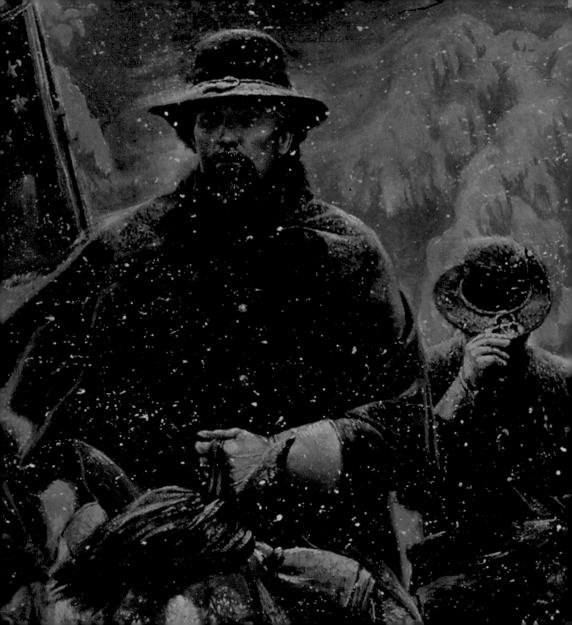

Bedford Forrest, objected to the proceedings and said, "I did not come here for the purpose of surrendering my command, and I will not do it if they follow me out."

So later that night, with about five hundred men from various commands within the fort, Forrest rode out under the foulest of weather conditions, through snow, ice, and freezing cold. He made it all the way to Nashville without encountering any Union troops. It was the first of many daring feats that Bedford Forrest would accomplish during the war.

In a night scene with snow and low visibility, one of my main problems is immediately identifying the troops as Confederate for the viewer. My solution was to place the flag bearer in a prominent position near Forrest. The flags of the Tennessee regiments surrendered at Fort Donelson were almost all variants of the first national pattern, the Stars and Bars. The Seventh Tennessee Cavalry flag has not survived, but it seemed safe to assume that it was a Stars-and-Bars pattern with thirteen stars. The state of Tennessee had issued a similar flag to all of its units in 1861, whether they were infantry, cavalry, or artillery. Many of the early flags had gold fringe.

I deliberately brought Forrest close up into the foreground so that his face would be readily recognizable. At night it would have been difficult to distinguish faces any farther back. I also purposely arrayed the other men in positions so that no other faces could be seen, thus focusing attention on the center of interest and the hero of the piece, the soon-to-be Brig. Gen. Nathan Bedford Forrest.

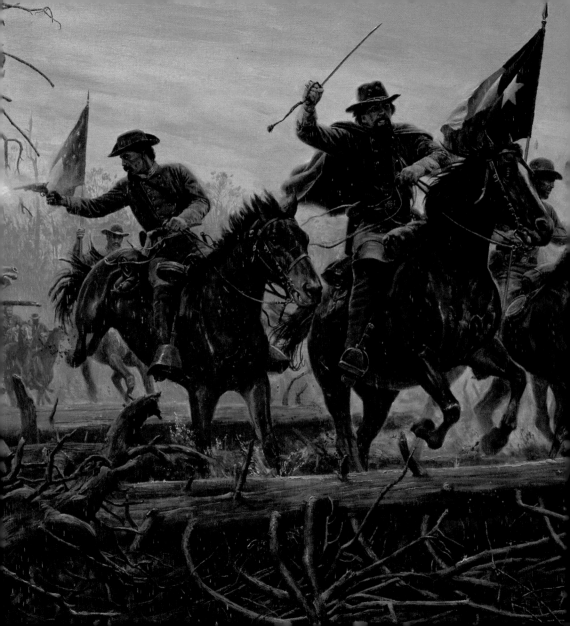

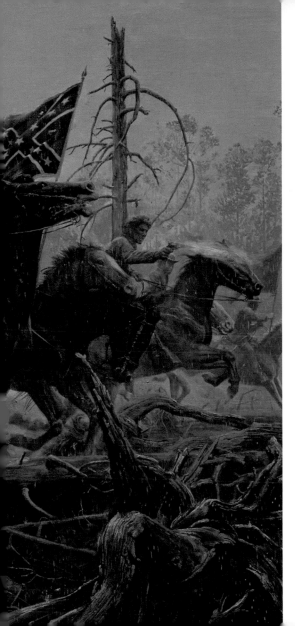

THE FIGHT AT FALLEN TIMBERS

COL. NATHAN BEDFORD FORREST AND
CAPT. JOHN HUNT MORGAN,
SHILOH, TENNESSEE, APRIL 8, 1862

1991, oil, 22 x 36

IN ADDITION to Nathan Bedford Forrest's escape from Fort Donelson in February 1862, I was fascinated by his exploits just two months after avoiding that unconditional surrender to Grant. On Tuesday, April 8, 1862, to be exact, events took place that were so exciting and action packed as to defy belief!

Forrest had been put in charge of 350 men, fragments of various cavalry commands—his own Tennessee regiment, Wirt Adams's Mississippians, John A. Wharton's Texas Rangers, and John Hunt Morgan's

127

Kentuckians—to act as a rear guard for the Confederate retreat after the defeat at Shiloh, also known as Pittsburg Landing. It was an opportunity for me to portray Forrest in action along with the soon-to-be-famous Morgan.

The weather was nasty, rainy; it hailed that night. The elements came together to create a great atmosphere for a painting.

While a regiment of Ohio infantry advanced toward Forrest through mire and a belt of fallen timber, instead of waiting to be attacked, the Confederate cavalry leader who came to be known as the Wizard of the Saddle decided to charge. In the painting, we see Forrest as a colonel, sword in hand, leading a dangerous charge over the fallen timbers with Morgan at his side. Although Forrest was born left-handed, because of the stigma attached to left-handedness in those days, he became ambidextrous.

During this fight, Forrest became isolated and surrounded by Union troops. As he fought his way out, he took a bullet in his left side, just above the hipbone, and it lodged in the left side of his back, near his spine. Supposedly, Forrest reached down, pulled up a Federal soldier, swung the man behind him to act as a human shield, rode off, and released his hostage when he was out of range. Forrest's horse died as a result, but the man lived.

In the painting, the Texas flag follows with the Confederate battle flag alongside. The first national flag, widely used at the time, is seen behind Morgan. In the extreme right background is the flag of the fourth unit.

The dead trees and fallen timber were perfect design elements to call attention to the center of interest—Forrest. This was my first effort to paint either Bedford Forrest or the battle of Shiloh. As two other paintings attest, it was not my last!

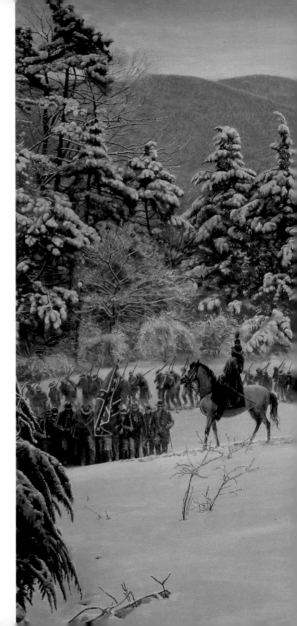

CONFEDERATE WINTER

GEN. RICHARD TAYLOR AT SWIFT RUN GAP,
VIRGINIA, MARCH 1862

1989, oil, 28 x 42

THIS PAINTING came about in an unusual way. I almost always take a specific event, research the facts I need for the basic work, and then try to create something I believe is good. In this case, I wanted to do a snow scene with a Civil War theme. I have also wanted to do a long view, a vista. So I decided to combine the two in this painting.

With few exceptions, no battles were fought during the winters of the Civil War. But there were a few necessary cold marches. I decided that a mountain view or pass would be ideal and looked for information about troop movements during inclement weather. After a little digging, I came

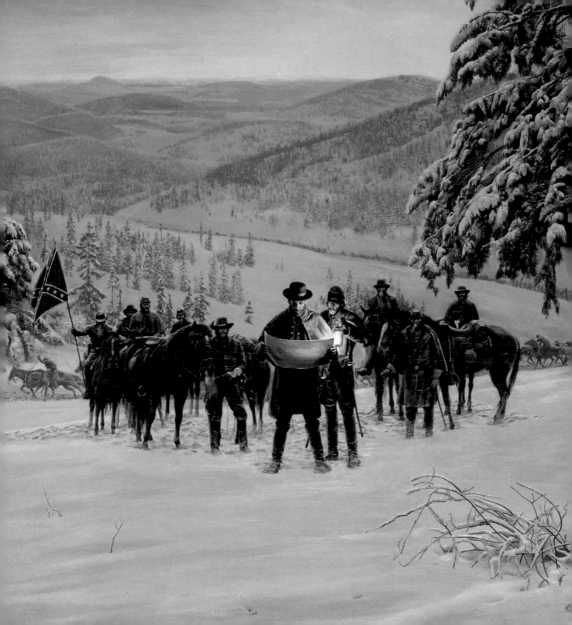

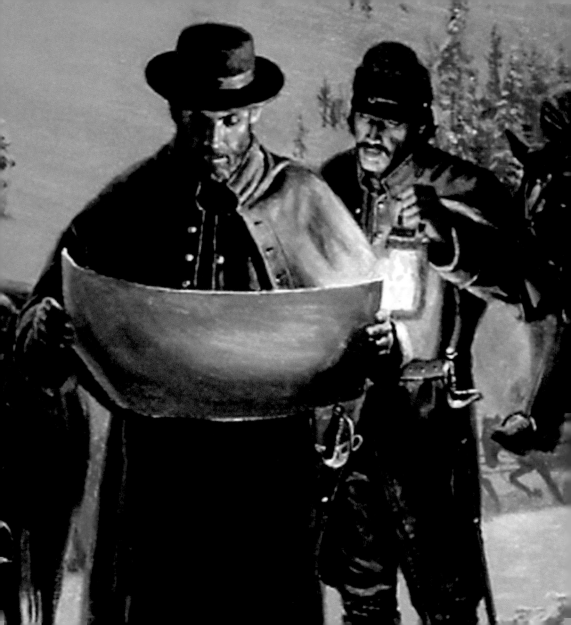

across Gen. Richard Taylor's Louisiana Brigade and some Virginia troops' passage through Chester's Gap, Virginia, in March 1862, under foul conditions. His troops were reinforcements for Stonewall Jackson's army and the upcoming spring Valley campaign. Thus I had the basic plot for my painting.

Taylor was thirty-six years old, a Yale graduate, son of former president Zachary Taylor, and brother-in-law to Jefferson Davis. He had no formal military training, but he had served as a secretary to his father during the Mexican War. James I. Robertson Jr., Jackson's biographer, observed that Taylor "had the intelligence and personal qualities to become a superior soldier."

His Louisiana Brigade was comprised of four regiments and an attached infantry brigade. The men were mostly immigrants, farmers, merchants, clerks, and general laborers. Every man in one unit had enlisted for the duration of the war, demonstrating a commitment to the cause that found expression in great pride as an efficient military force. The last unit was probably the most colorful: Roberdeau Wheat's Louisiana Tigers, which included soldiers of fortune and criminals. So rowdy were these men that few units welcomed them when they

tried to enlist. But their "enthusiasm" translated into fierceness on the battlefield. Thus the Louisiana Brigade exemplified the kind of military machine Jackson needed.

I started with the view and the knowledge of where the old road lay in the gap. I wanted to show the entire force. Taylor (holding the map) and his staff lead the first regiments, followed by a battery of artillery, struggling through the snow, mud, and uphill course of the road. Then followed the next regiments and finally the supply wagons, bringing up the rear in the far distance.

Taylor's likeness is based on a photograph. The idea of a twilight scene is something that has always appealed to me, but is difficult to illustrate. By using a lantern, I was able to use the contrasting warm light to accentuate the center of interest and emphasize the cold evening lighting.

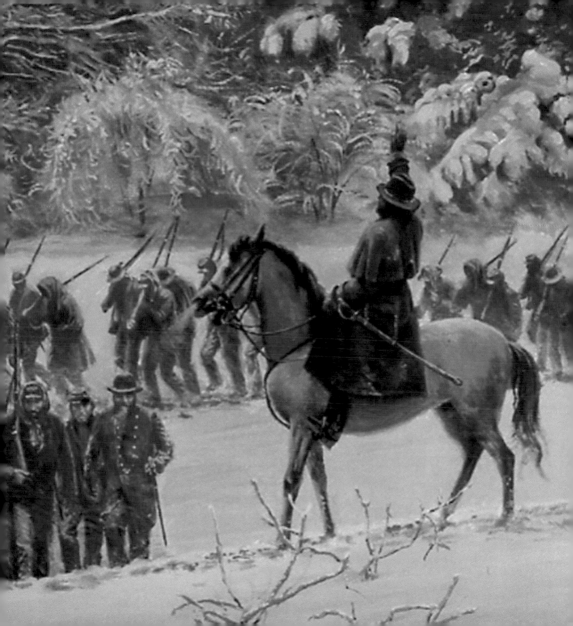

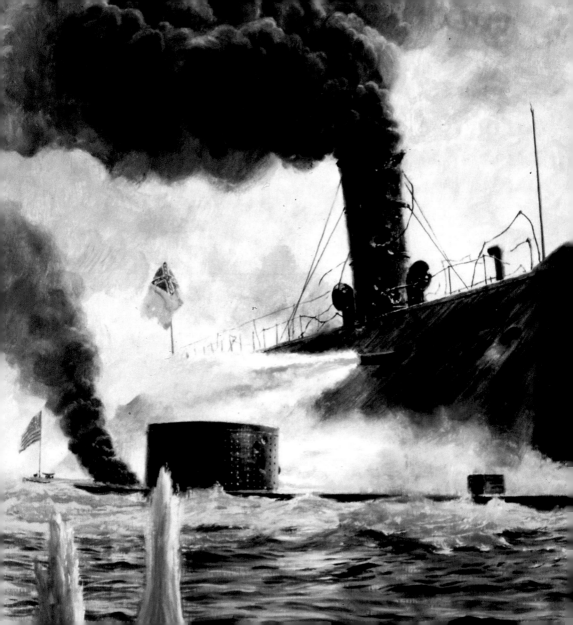

THE USS *MONITOR* AND THE CSS *VIRGINIA*

HAMPTON ROADS, VIRGINIA
MARCH 9, 1862

1985, oil, 12 x 14

As soon as the North learned that the South was constructing an iron-clad ship, contracts were offered and executed for Union ironclads. By sheer chance, after the CSS *Virginia* sailed into Hampton Roads on March 8, 1862, and wreaked havoc on the Union fleet there, sinking or disabling three warships, that night the uncon-ventional USS *Monitor* arrived on the scene. The next day the two peculiar vessels battled to a stalemate. They never fought again, but the *Monitor* prevented the *Virginia* from attacking the Union blockade. Neither ship sur-vived the war, but they ushered in a new age in maritime warfare.

137

GENERAL THOMAS J. "STONEWALL" JACKSON

WINCHESTER, VIRGINIA
MAY 25, 1862

1988, oil, 30 x 48

THIS IS one of my first paintings of Thomas J. Jackson, and it is one of the most celebrated of my collection.

Jackson rose from a hardscrabble childhood as an orphan to be acclaimed as an American military genius. In 1861, this obscure instructor from the Virginia Military Institute gained enduring fame in battle as "Stonewall" Jackson—then he transformed his fame into legend with the extraordinary and victorious Valley campaign of 1862. Jackson would

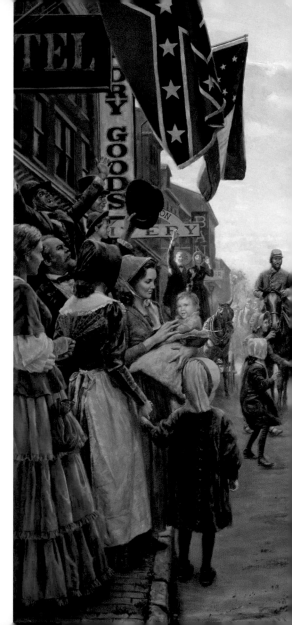

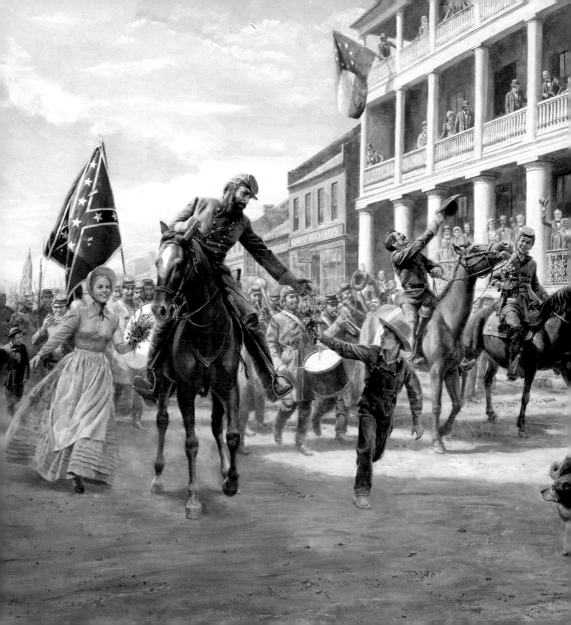

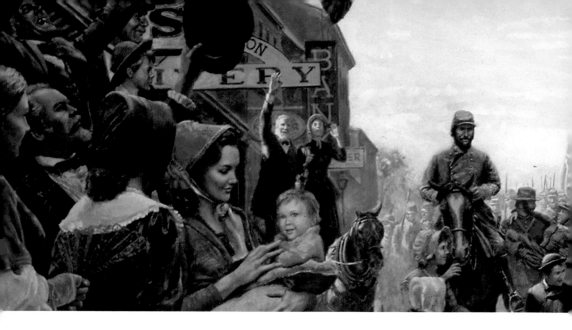

earn his mantle of military greatness as Robert E. Lee's unsurpassed "right arm" between the battles of Second Manassas and Chancellorsville.

At the height of his great campaign in the Shenandoah, Jackson and his army swept into Winchester as Union forces fled northward in defeat. The Fifth Virginia Infantry of Jackson's original command, the Stonewall Brigade, led the way into Winchester, and the townspeople flocked to the streets to welcome their liberators. Despite the dust and smoke from battle, many of the faces were familiar to the townspeople since Winchester was the soldiers' hometown. Confederate flags, hidden in closets and trunks, suddenly appeared from windows, and the rush through the streets became a parade. Caught up in the spirit of the moment, Jackson accepted the acco-

lades of the grateful citizens suddenly free from the Union occupation they had endured.

At this moment, Jackson reached the zenith of his career, rising from the defeat of Kernstown to clear the Shenandoah Valley of Federal forces within two months. The citizens of Winchester not only applauded the victorious general, they knew they were gazing on a legend.

The celebration was brief for Jackson. To the north, the sound of firing could be heard. And so Jackson pressed on, the greatest victory of his brilliant Valley campaign nearly over, leaving only the legend behind.

The inspiration for this painting came from Jackson himself. In a letter to his wife, he mentions, "I do not remember ever having seen such rejoicing. Our entrance into Winchester was one of the most stirring scenes of my life."

Starting with this, I went to Winchester to research the painting. Rebecca Ebert and Ben Ritter, both of the Winchester Library, and the Winchester Historical Society helped immeasurably in my work. Their archives held old photographs and town records, which aided me in determining what the city and streets were like at the time of Jackson's triumphal entry.

The key focus of this scene is Taylor's Hotel, a famous landmark that was used as headquarters by Jackson's opponent, Gen. Nathaniel Banks. Recently the hotel was voted the most famous building in Winchester. The building has changed quite a bit since the war and in the 1980s housed a drugstore.

The other buildings and signs in the painting are based on facts gleaned from the archives and other sources. The Russel and Green Dry Goods Store was next to the Taylor Hotel. Bell's Book Store was adjacent to that. Across the street was another hotel, the Washington. A dry goods store farther up

the street and other shops are situated as accurately as possible. In the lower left corner, you can see the brick sidewalk and stone curbing that still exists on some Winchester streets.

The flags are based on the flags of the Confederacy in 1862. You can see the national flag as well as copies of the battle flag, similar to the style used in the field. I tried to impart as much excitement and joy as possible since this was the first time that Winchester had been liberated from a long and reportedly harsh occupation, with the Confederates being welcomed as conquering heroes. There are descriptions of flowers being given to the soldiers. Since many of the troops came from Winchester itself, you can see one soldier embracing his girlfriend or wife, and on the right, in front of Taylor's, another kisses his loved one.

Of the four mounted officers, Jackson is the center of interest, deliberately silhouetted against the sky with all focus on him, followed by staff officers. On the left, riding in the background, is Maj. Robert Dabney. The officer to the right of Jackson, waving his hat to friends on the hotel balcony, is Dr. Hunter McGuire, who lived in Winchester after the war and whose house I visited during my research. The last officer is Maj. Henry Kyd Douglas, a noted biographer of Jackson.

Behind the officers march troops of Jackson's old brigade, led by the famed Stonewall Brigade band, which was primarily made up of brass and drums. In addition to their instruments, the band members also fought and acted as couriers and letter bearers. During peaceful interludes, the band visited small towns and gave concerts in order to spur enlistments and raise relief funds for soldiers' families.

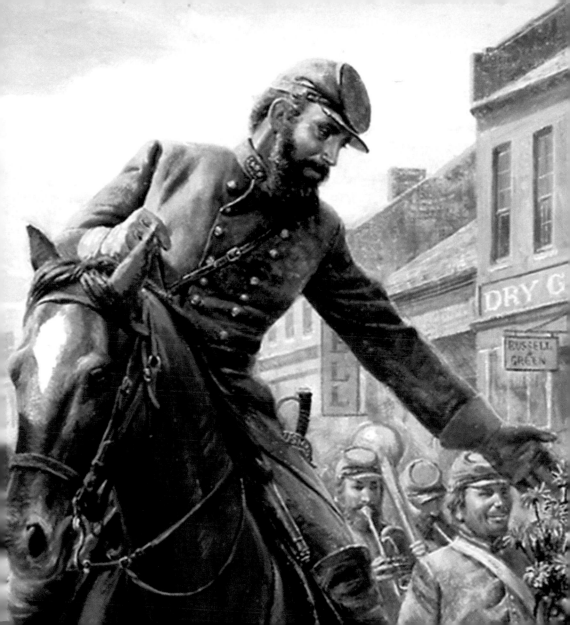

Jackson's army entered Winchester on May 25, 1862, at about 10 o'clock in the morning. To get the same lighting effect at that time of year was difficult, because I was not able to visit the area on that particular date. But toward the end of July, when I did visit, it was one month past the spring equinox, and the lighting effect was virtually the same as on May 25.

The troops came in from the south. At that hour of the morning, the buildings cast a dramatic light-and-shade pattern on the street that enabled me to highlight the center of interest: Jackson and the Confederate flag.

When I do a painting of this sort, I try to put myself in the place of each person there and ponder what they would be feeling and doing at that mo-

ment. Very often, there are interactions among the characters, one with another. I do this exercise with each figure. If you see a disconsolate figure, it's perhaps a wife waiting anxiously for a glimpse of her husband in the ranks. When you see cheering people, you know that they have suddenly sighted a dear one who has come back from the battle.

The subject of the painting is Jackson's supreme moment of triumph in the Valley campaign. In some ways, it's a family moment, both in terms of family members in the ranks and the adoption of a Virginia orphan by an entire town, an entire region. I consider it one of my most pleasurable paintings, and I hope viewers enjoy it half as much as I enjoyed painting it.

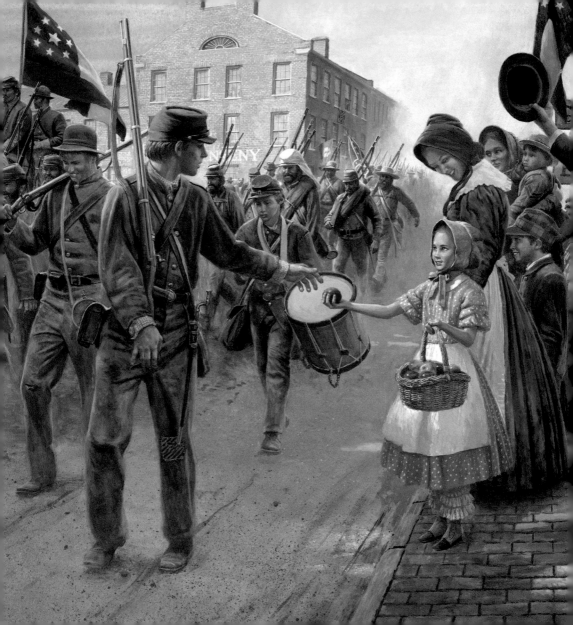

ESPECIALLY FOR YOU

WINCHESTER, VIRGINIA
MAY 25, 1862

2006, gouache, 19¼ x 20½

THE SETTING of this painting is Winchester, Virginia, the same as the preceding painting, *General Thomas J. "Stonewall" Jackson*, but from a different perspective. Here, the focus shifts to the soldiers in the ranks. The center of interest is a young girl who is presenting an apple to a young infantryman. Her mother looks on proudly, and behind—watching appreciatively—is a woman with a little boy in her arms. And an older boy excitedly absorbs the scene.

To emphasize the apple, I placed a drum directly behind the girl's hands. I used the dappled sunlight coming through a tree to spotlight the girl and the soldier. In the background is the Senseny Building, which I've described earlier on pages 60 and 103.

I could have painted a similar scene of Northern troops leaving home for war or marching through Pennsylvania in 1863. Thus the painting represents the American heart: an optimistic willingness combined with a sense of duty that allowed them to endure to the end for what they believed was right. It was this heart that makes the war so tragic, but it was also this heart that later reunited the nation.

147

LEE TAKES COMMAND

PRESIDENT JEFFERSON DAVIS AND
GEN. ROBERT E. LEE, MAY 31, 1862

2004, oil, 22 x 40

detail, right

ELEVEN WORDS changed the course of the war: "General Lee, I shall assign you to command of this army."

They were spoken by Jefferson Davis during an evening ride after his army's commander, Gen. Joseph E. Johnston, had been seriously wounded in an engagement at Seven Pines. And now Union Gen. George B. McClellan's seemingly unstoppable army threatened the outskirts of the Confederate capital.

Who would now take command of the forces defending Richmond? If the capital fell, the fledgling Southern nation would surely collapse.

Riding back toward Richmond through the darkness on Nine Mile Road, the Confederate president turned to his chief military adviser, fifty-five-year-old Robert E. Lee, and named him as Johnston's successor. Although Lee had opposed secession, he was committed to defending his homeland from invasion, and he obediently accepted command.

Within a month, he had driven McClellan's army from the field and had reformed his command into what would become the heralded Army of Northern Virginia. By war's end, he had established a reputation of competence and

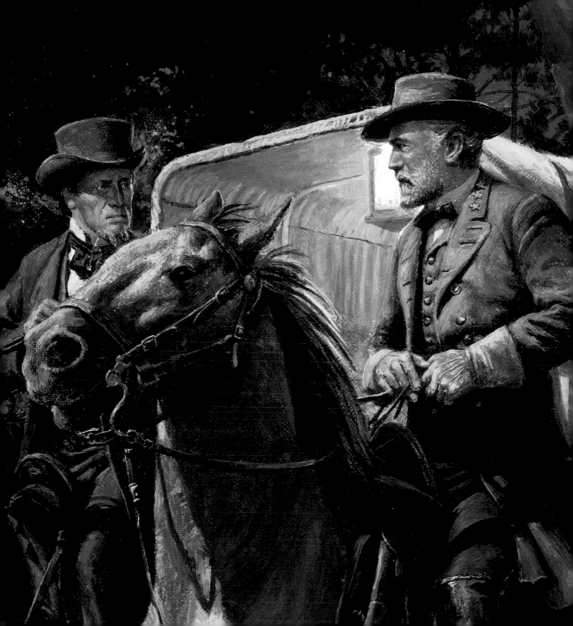

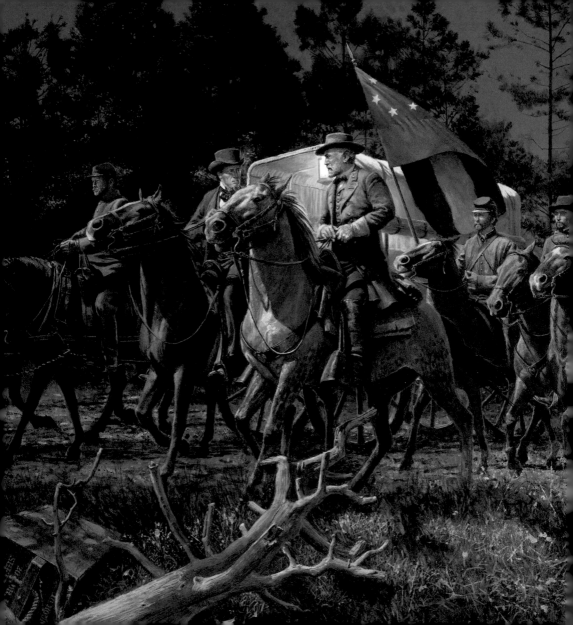

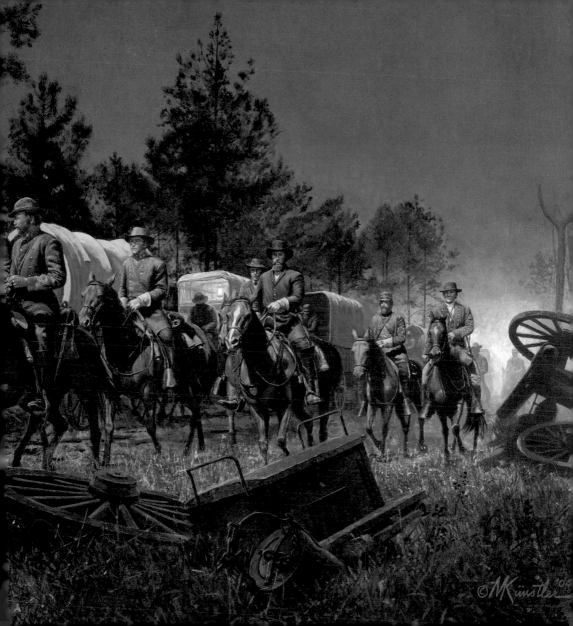

character that was revered throughout the South and respected across the North—a legacy that would make Robert E. Lee the most admired military leader of the Civil War.

Oddly, no major work of art had ever depicted this crucial moment before. And I had wanted to paint it for a long time. For ten years I gathered information here and there and contemplated the painting's composition.

I used a number of elements to highlight the two main figures and the key exchange between them. A low eye level creates a triangular composition with Lee at the apex. I then placed the flag at a point where it heightens that high point and adds color to the visual center of interest. By situating the lantern of the ambulance wagon directly behind Lee's head, the warm light contrasts with the cool moonlight, leading viewers to focus on Lee.

Davis's and Lee's staffs follow the two men. Professor James I. Robertson Jr. supplied details about the weather conditions on that last day of May 1862, which was very important. For instance, no dust is being kicked up by the horses because a heavy rain had fallen recently. I have spent a lot of time with horses, so I painted the tired mounts with their heads high in anticipation of being fed once they were back in their Richmond stables.

George Hicks, CEO of the National Civil War Museum in Harrisburg, Pennsylvania, graciously allowed his staff to provide information on Civil War ambulances. The museum collection includes a period ambulance in superb condition, which was very useful to study.

This is the kind of scene I love to paint. It's filled with fascinating details, depicts the everyday objects of life during that time, and preserves a pivotal moment in the history of the Civil War.

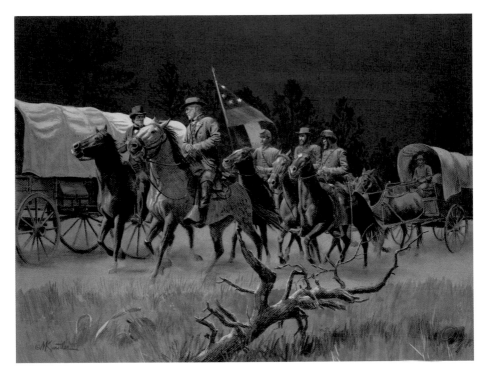

PASSING OF COMMAND

STUDY

1995, mixed media, 18½ x 25

STUART'S RIDE AROUND McCLELLAN

JUNE 13, 1862

1995, gouache, 17 x 38

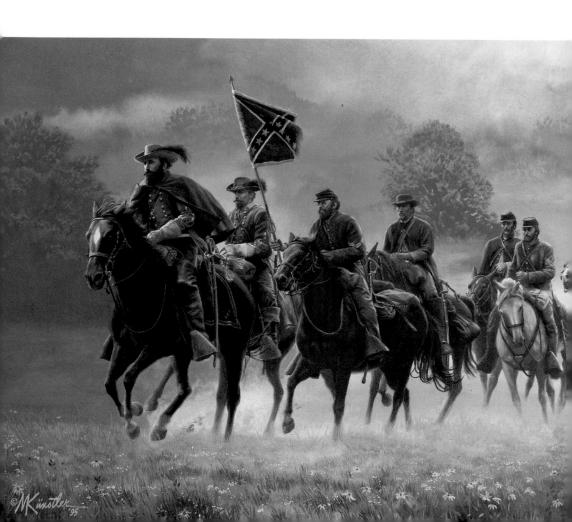

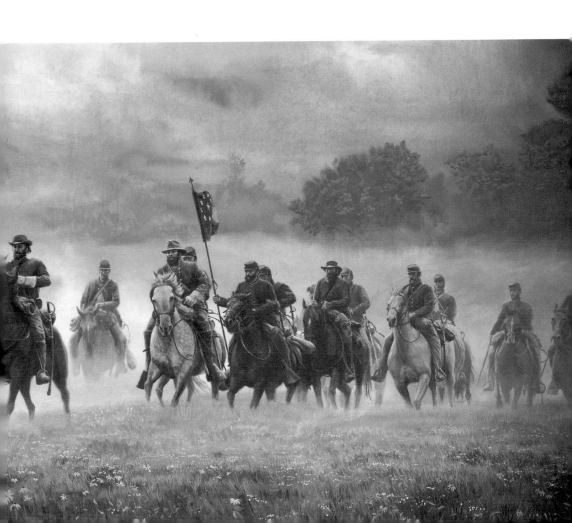

How DOES one best depict Gen. James Ewell Brown "Jeb" Stuart, the South's most famous and flamboyant cavalry commander? That's the question I had to weigh as I prepared to paint. I knew I wanted to paint Stuart—but how? In what setting? I decided there was no event that better typified the daring Stuart than his famous "Ride Around McClellan" in 1862.

Robert E. Lee, who had just taken command of the army in defense of the Confederate capital, should have been planning how best to protect Richmond from George B. McClellan's gigantic army, which had been steadily progressing up the Virginia Peninsula. Instead, Lee was thinking of how he could attack McClellan. And to do so, there was much he needed to know. So he ordered Stuart to "gain intelligence for the guidance of future operations."

On June 12, 1862, Stuart set out with twelve hundred horse soldiers, heading westward, as if his force were moving to the Shenandoah Valley to reinforce Southern troops there. A day later, on the morning of June 13, 1862, he changed direction and headed to the east—and then his men knew that Stuart was leading them in a dangerous, risky raid against McClellan's powerful army.

This was a dramatic moment, and I like the way historian Douglas Southall Freeman describes it: "The moment it turned toward the East, a stir went down the files . . . the men had suspected that McClellan's flank was their objective, and now they knew it. The day for which they had waited long had come at last. They were to measure swords with the enemy."

In this painting, I tried to capture the drama of that moment. Stuart rides at the head of his troops, his ostrich plume is in place and his red-lined cape

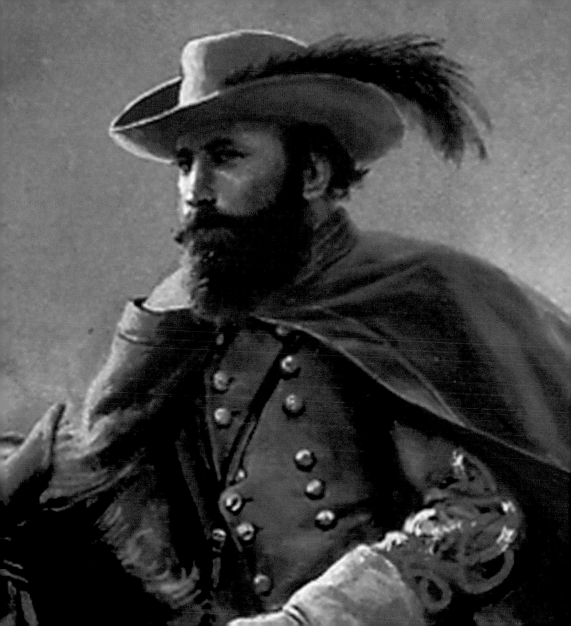

flapping behind him. As the column cuts across a grassy pasture heading for easterly roads, the early morning sun highlights his face and the unfurled battle standard behind him.

Riding closely behind Stuart is Maj. Heros Von Borcke, the general's towering German aide. Directly behind the flag-bearing corporal is John S. Mosby, half aide, half courier, already demonstrating the qualities that would bring him future fame as the Gray Ghost.

Leading the second group of riders, under the first national flag, is Robert E. Lee's son, Col. William Henry Fitzhugh "Rooney" Lee of the Ninth Virginia Cavalry. I tried to capture the determination of these young soldiers as they set out on a daring raid against a vastly stronger enemy.

It wasn't until June 15 that Stuart returned to headquarters, bedraggled but triumphant and full of information. His ride around McClellan made him the most famous cavalry officer of the war, and for a time his star shined brighter than Stonewall Jackson's. But more important, Lee gained a confidence in Stuart to where he truly became the eyes of Lee's army.

From Stuart, Lee learned that McClellan was vulnerable. He shifted two-thirds of his army toward the weak spot, and he summoned Jackson from the Valley. The end result was the first offensive of the Army of Northern Virginia, which began on June 25 at Oak Grove and ended at Malvern Hill on July 1. Known as the Seven Days' battles, Lee's legacy began with McClellan's retreat, precipitated by Stuart's one-hundred-mile expedition.

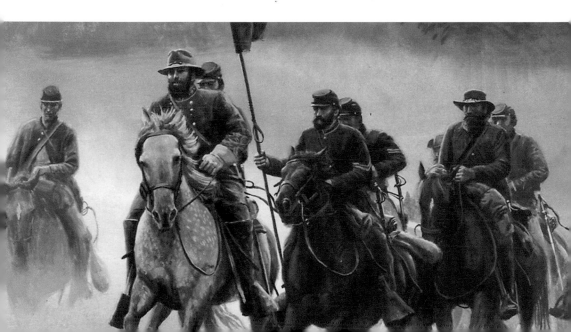

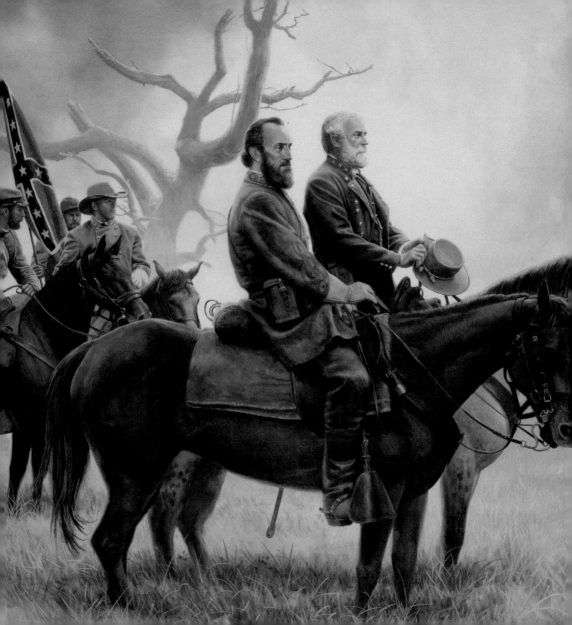

"... THEY WERE SOLDIERS INDEED"

GENERALS JACKSON AND LEE
GAINES'S MILL, VIRGINIA
JUNE 28, 1862

1995, gouache, 19⅛ x 29¼

THE LARGEST and costliest of the Seven Days' battles was at Gaines's Mill on June 27. Lee's only outright victory of the campaign came when John Bell Hood's Texas Brigade charged and broke the Federal line. The battle was the costliest of the Seven Days; together, both sides tallied more than fifteen thousand casualties.

The next morning, Jackson and Lee surveyed the ground where the Confederates had charged. Jackson exclaimed, "The men who carried this position were soldiers indeed!"

The Seven Days was the beginning of the Lee and Jackson partnership that catapulted Southern hopes to heights not known since the days of bravado that enervated so many during the months of secession conventions. Jackson and Lee shared a desire to fight offensively and a determination to win.

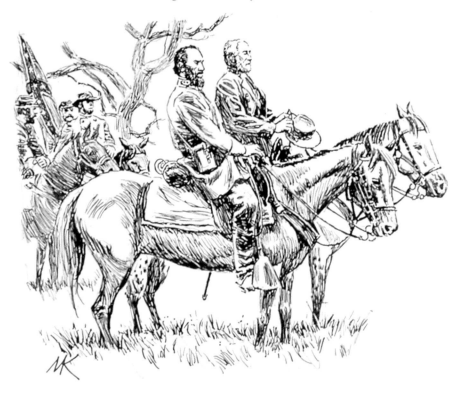

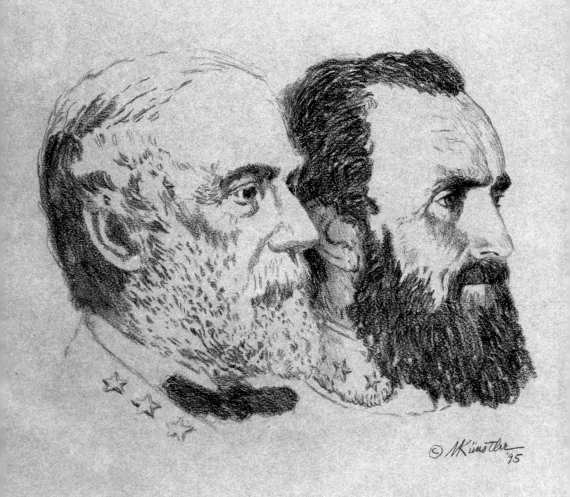

WHITE HOUSE STRATEGY

LEE, JACKSON, AND DAVIS

JULY 13, 1862

2005, oil, 32 x 28

IT WAS a meeting like no other. After the Seven Days' campaign, Gens. Robert E. Lee and Thomas J. Jackson conferred with President Jefferson Davis at the Confederate White House in Richmond. Meeting in the president's upstairs office, they developed the strategy for what would become the Second Manassas campaign. What impressed me most about this meeting was that it was a unique council, the only meeting of the South's three principal commanders at the Confederate White House.

I never tire of visiting the White House of the Confederacy. It's so well preserved, and the architecture and furnishings are extraordinary. After a tour of the adjacent Museum of the Confederacy, a visit to the Confederate White House makes history come alive for me. On my last visit, I thought about so many opportunities for paintings in the White House. Then I realized that no artist had ever painted the only time that Davis, Lee, and Jackson met alone together there. And I realized that this would be one of the few Civil War paintings that I've done with an interior setting.

One of the biggest challenges in painting a scene such as this is finding accurate likenesses of the people involved. In this case, it was particularly

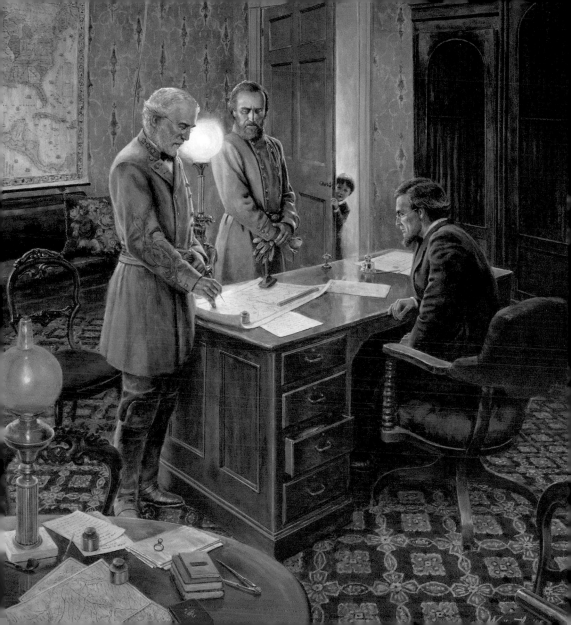

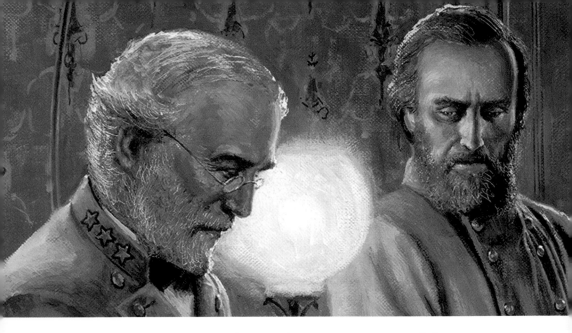

difficult. There are no photos of Lee, Jackson, or Davis as I needed to position them in this painting. We see photographs of each of them often, but they're the same small number of images—all from a certain angle. Painting Davis was especially challenging because there are no photos of him in profile.

I learned from the historical staff at the White House of the Confederacy that Davis, like Abraham Lincoln, allowed his children to run freely throughout the house with few restrictions—even when important meetings and affairs of state were being conducted.

The president's oldest son, Jefferson Davis Jr., was a precocious and rambunctious child, dubbed "the General" by the White House staff. And with the nursery adjacent to the president's office, the five-year-old often popped into his father's office unannounced. Thus it did not stretch credibility to

imagine that the youngster might peek in on this unique occurrence, glimpsing the great men at work.

Davis's office is on the second floor of the White House and has been beautifully restored. The carpeting, wallpaper, furniture, and artifacts are there for visitors to see, and they are the basis for what I show in my painting. Of special note is the lamp on the desk that I

used to dramatically emphasize Lee and Jackson. It was a gas lamp that was fed from the chandelier above with a hose that can be seen above Lee's head. I'm thankful to the White House of the Confederacy's very knowledgeable experts, Robert Hancock and Dean Knight, for their invaluable assistance in such details.

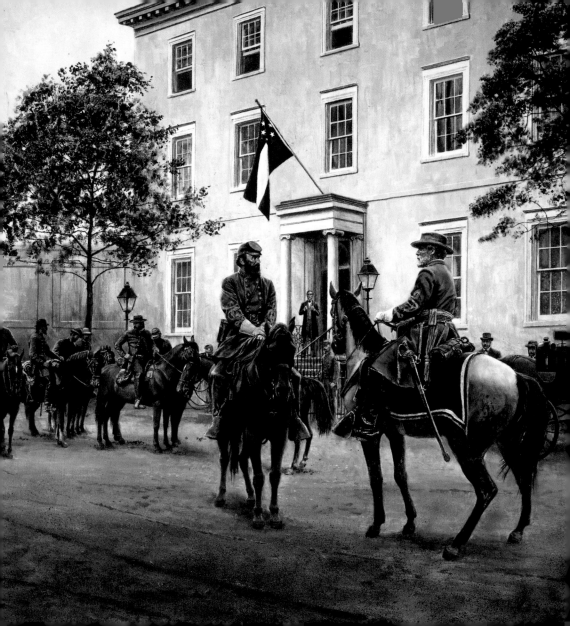

THE HIGH COMMAND

CONFEDERATE WHITE HOUSE

JULY 13, 1862

2000, oil, 28 x 30

AFTER THEIR meeting with the president, Lee and Jackson lingered outside for a short while. I viewed this as another opportunity to show the three men together at the White House as well as a chance to depict the exterior of the building.

After studying the White House from every angle, I chose to compose the painting to show its three floors and distinctive roof and to show it as most people see it today while driving or walking down Richmond's Twelfth Street.

Postwar photographs and an Alfred R. Waud drawing showed the sizes and locations of the trees, lampposts, and carriage block. There were usually waiting carriages and civilians outside.

A letter by Capt. Charles Blackford, recently assigned to Jackson's staff, described the fine, elegant manner in which Lee was dressed that day. Jackson wore his usual field dress, which was cleaned up somewhat for this major conference. At the extreme left of the picture is Jackson's entourage, which had accompanied the general on his ride from the front.

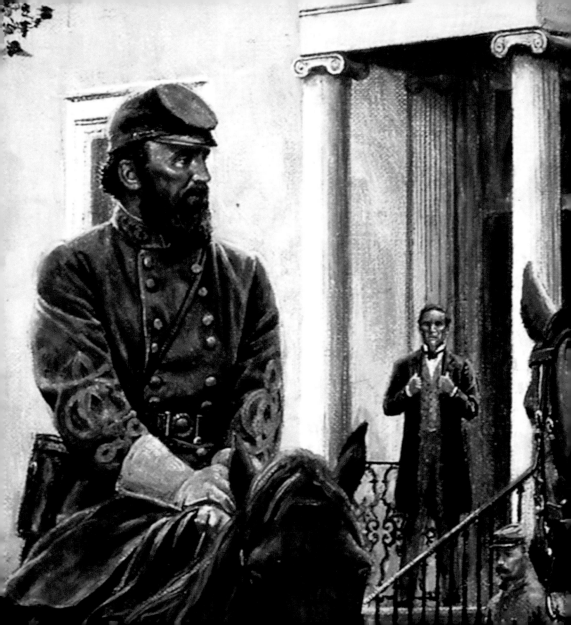

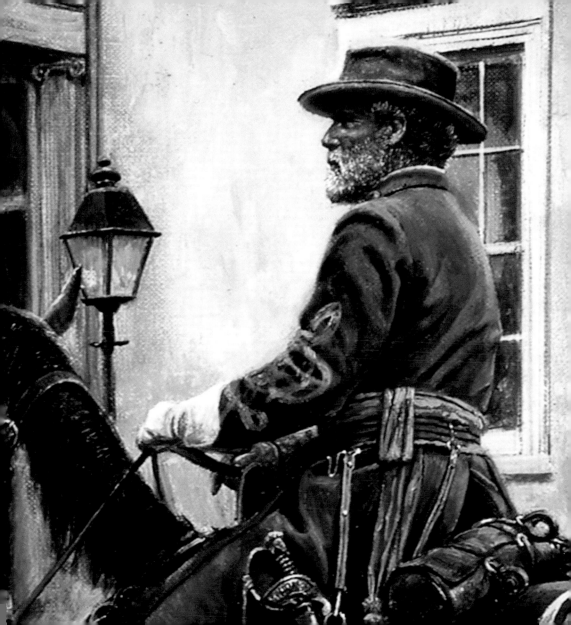

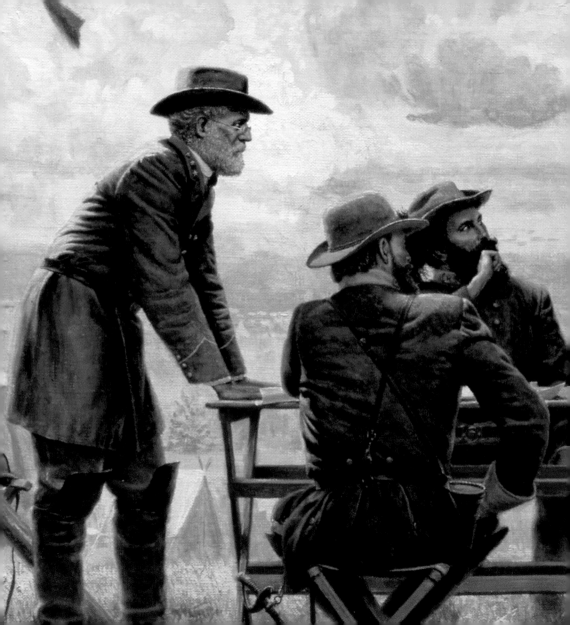

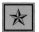

"I WILL BE MOVING WITHIN THE HOUR"

SECOND MANASSAS CAMPAIGN, AUGUST 24, 1862

1993, oil, 20 x 40

detail, left

THE STRATEGIC planning that always seemed to precede great victories by Lee and Jackson fascinates me. This painting depicts a unique, crucial battle conference with Lee, Jackson, James Longstreet, and Jeb Stuart at the beginning of the August 1862 Second Manassas campaign.

I found a description of the proceedings in the memoirs of Maj. Henry Kyd Douglas, one of Jackson's staff officers. Longstreet's *From Manassas to Appomattox,* mentions the same meeting, as does Douglas Southall Freeman's *Lee's Lieutenants.* Douglas's memoirs reported:

173

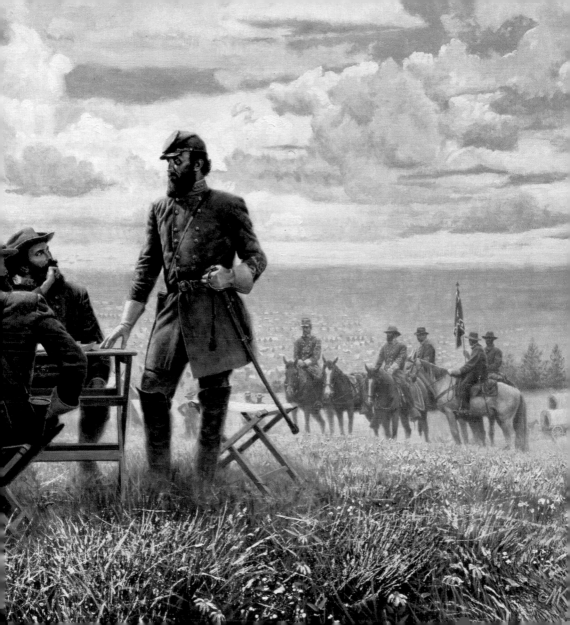

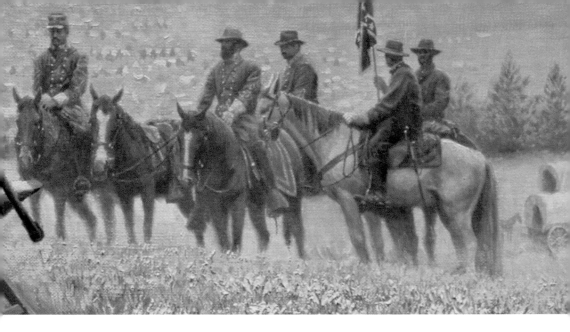

A council of war was held at the General's headquarters that afternoon. It was a curious scene. A table was placed almost in the middle of a field, with not even a tree within hearing. General Lee sat at the table on which was spread a map. General Longstreet sat on his right, General Stuart on his left, and General Jackson stood opposite him; these four and no more. . . . The consultation was a brief one. As it closed I was called by General Jackson and I heard the only sentence of that consultation that I ever heard reported. It was uttered by the secretive Jackson, and it was, *"I will be moving within the hour."*

Per Douglas's description, I placed Lee, Jackson, Longstreet, and Stuart at a small table in the middle of the grassy field, surrounded by terrain typical of the Manassas region. Nearby, above Lee's headquarters tent, the first national

flag of the Confederacy is ruffled by a breeze, alongside the Confederate battle flag. The elevated viewpoint provides the opportunity to depict the soon-to-become-legendary Army of Northern Virginia—troops, tents, wagons, etc.—sprawled across the scenic Virginia countryside.

In a daring military gamble, Lee would nearly abandon the Confederate capital's defenses to execute a brilliant tactical maneuver. What followed was a deep raid into Federal territory near the old Manassas battlefield to draw in the newly formed seventy-five-thousand-man Army of Virginia commanded by Union Gen. John Pope, which was marching on Richmond.

Lee sent Jackson westward, seemingly returning to the Shenandoah Valley. But the men of the Valley were to circle back and destroy the Union supply depot at Manassas Junction. Then Jackson was to dig in, wait for Pope's army, and challenge him. Once he had engaged Pope, he was to keep him occupied until Lee and Longstreet arrived with the rest of the army. And all of this had to happen before McClellan's Army of the Potomac could join the battle.

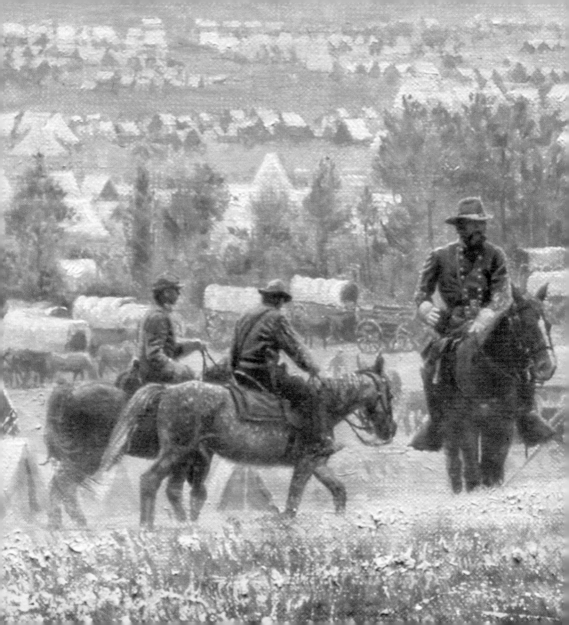

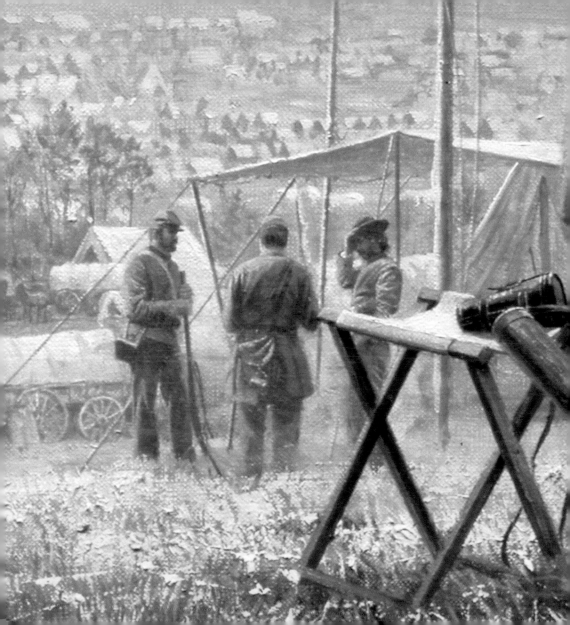

WITH A REBEL YELL

SECOND MANASSAS, AUGUST 29, 1862

2002, gouache, 15⅞ x 38¼

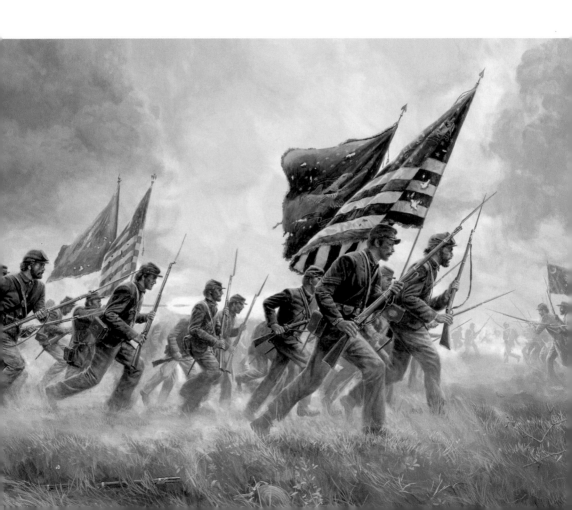

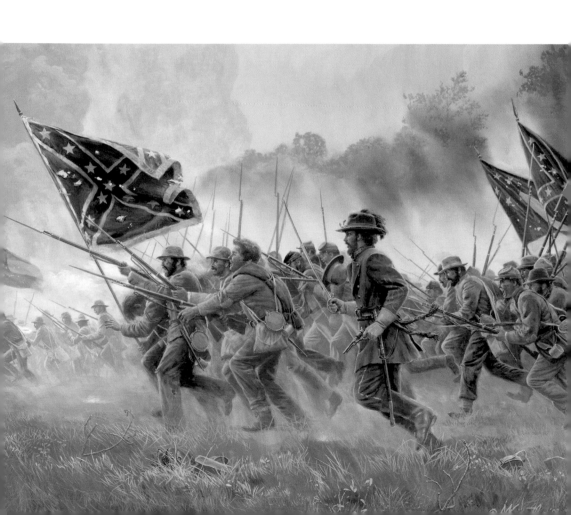

THOSE WHO heard it never forgot it. Such was the power of the legendary Rebel Yell. It was an odd mixture—part hunting shout, part hog-call, part excitement, part fear, and part bravado. Recalled a Civil War veteran: "Then arose that do-or-die expression . . . that penetrating, rasping, shrieking, blood-curdling noise that could be heard for miles on earth." Those who shouted it said it could never be duplicated outside of battle.

Among the numerous battlefields over which the Rebel Yell reverberated was Second Manassas, where Confederates found themselves sorely pressed on the first of three days of fighting there.

For two days, the armies launched a series of bloody assaults against each other. At one point, the Confederate left flank was struck a fierce blow by courageous Federal troops from New York and Pennsylvania. The men in blue hammered at two brigades of Carolina troops under Gens. Maxcy Gregg

and Lawrence O'Bryan Branch. Exhausted, low on ammunition and depleted by heavy casualties, the valiant Carolinians braced for another attack. Just when the Southern line seemed on the verge of breaking, fresh Virginia troops under Gen. Jubal A. Early joined the battered Confederate defenders and struck the advancing Federals head-on in an open meadow.

The Southerners charged into the fighting, a veteran of the battle recalled, "with a wild Confederate yell." The two forces collided in a hand-to-hand, face-to-face struggle—and then the Northern line broke and fell back in retreat. The next day the Southern success would be repeated, and Second Manassas would go down in history as one of Robert E. Lee's greatest victories. It would also remain a reminder of that uniquely Southern phenomenon, the Rebel Yell, an audible and ecstatic expression of the decidedly Southern, almost joyful, all-or-nothing attitude that carried the Southern Cross above countless fields of fire.

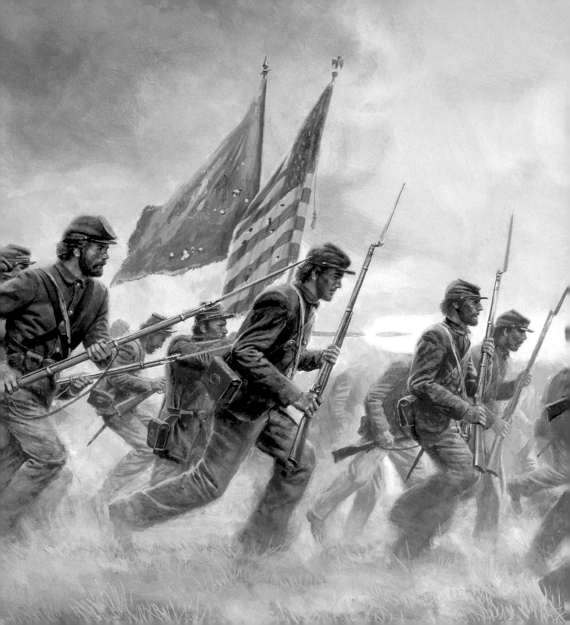

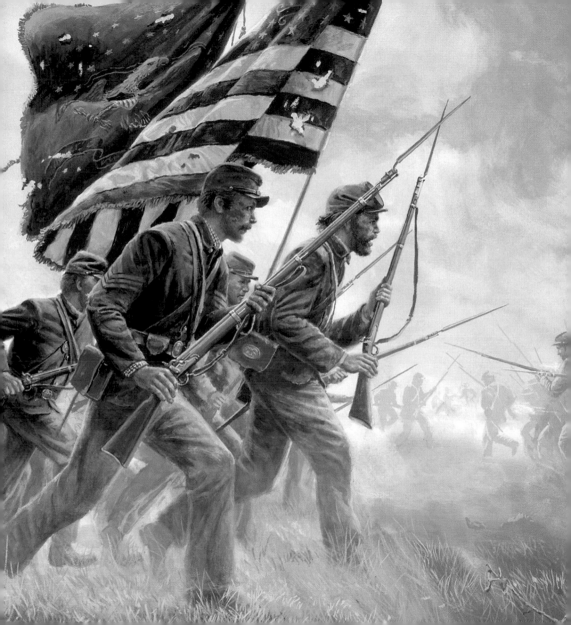

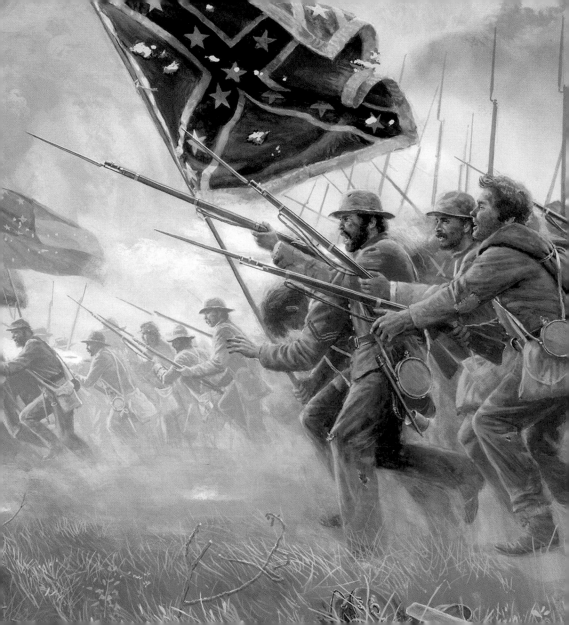

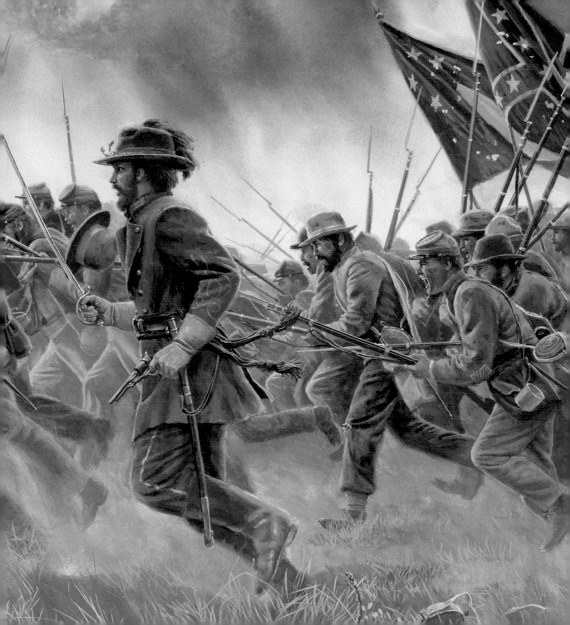

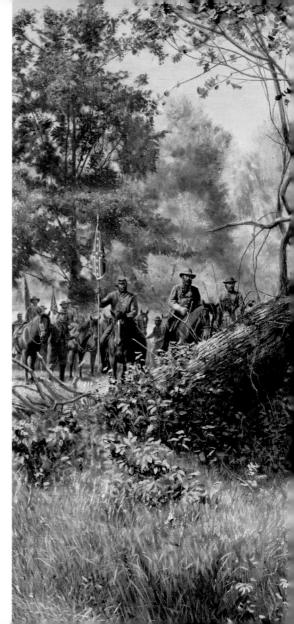

THE COMMANDERS
OF MANASSAS

GENERALS LEE, LONGSTREET, AND JACKSON
AUGUST 29, 1862

1996, oil, 28 x 38

ON THE rolling fields of Manassas
the battle unfolded before them.
From the crest of Stuart's Hill, Gens.
Robert E. Lee, James Longstreet, and
Thomas J. Jackson watched as Lee's
army engaged John Pope's Federal
troops in a distant swirl of dust and
smoke. Jackson had opened the battle
the day before, stunning Pope's
troops with a mighty blow at nearby
Groveton. Now Pope had launched
the first in a series of uncoordinated
assaults that yielded his army nothing
but bloody losses.

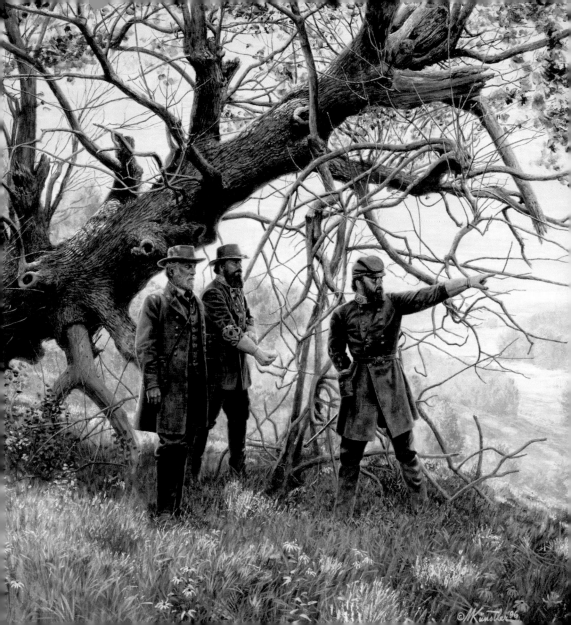

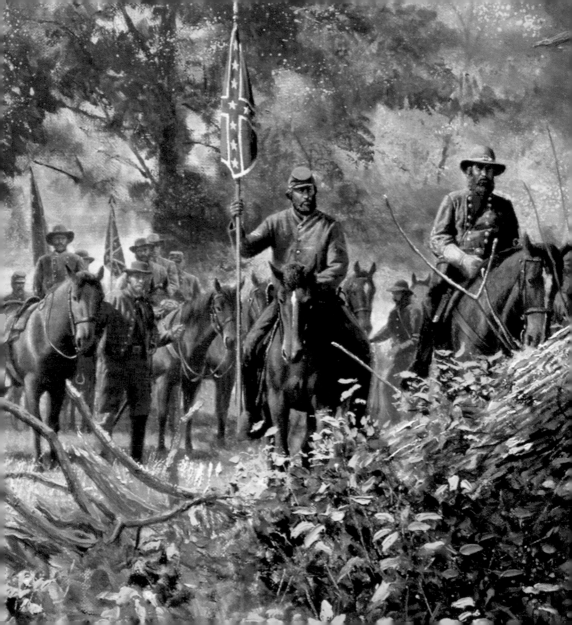

On August 29, Lee and Longstreet joined forces with Jackson at Manassas Junction. They found him on the hill that afternoon, watching as fighting again engulfed the countryside below, where the war's first major land battle had occurred a year earlier. Now, on the old battleground, Lee's magnificent maneuvering lured Pope's army into a tactical contest that Lee would win decisively. The next day, Jackson and his veterans would again stand against the enemy at Manassas like a stone wall; Longstreet would launch a shattering attack against Pope's poorly led forces; and the Federal army again would flee this ground in disarray.

This action was the closest the Army of Northern Virginia would ever come to destroying another army. In less than three months since he had taken command, Lee had reversed Southern fortunes dramatically. In late June, the Confederate capital was poised for capture. At the end of August, Washington, D.C., stood vulnerable before Lee's army. Under Lee's leadership, two massive Union armies had been driven out of Virginia within a span of two months.

The battle of Second Manassas would prove to be one of Robert E. Lee's most masterful victories, stalling yet another Northern advance on Richmond but also clearing the way for an invasion of the North. Southern triumph and Northern failure became the dominant theme of any action in the eastern theater for almost a year. And Lee, Jackson, and Longstreet would be remembered as the invincible architects of this development for the rest of 1862.

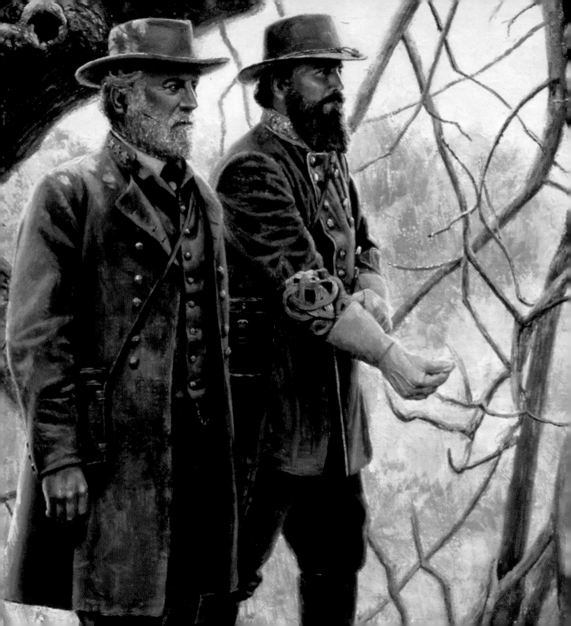

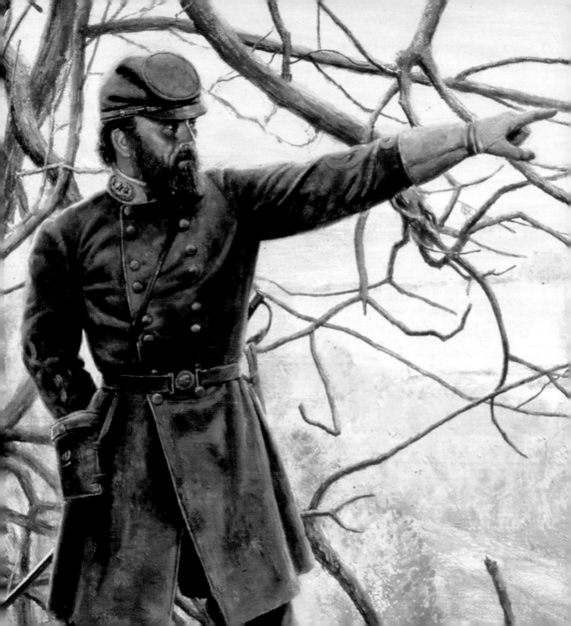

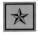

GODS AND GENERALS

ANTIETAM CAMPAIGN, LEESBURG, VIRGINIA,
SEPTEMBER 5, 1862

2002, oil, 24 x 34

IT WAS a meeting that could determine the outcome of the war. After the brilliant victory at Second Manassas, Robert E. Lee intended to lead his Army of Northern Virginia into enemy country to shift the focus of the war in the east off Virginia and take the fighting to the North. Along the way, he hoped to enlist crucial support from Southern sympathizers in Maryland and perhaps even provoke official recognition of the Confederacy by Great Britain. If he could

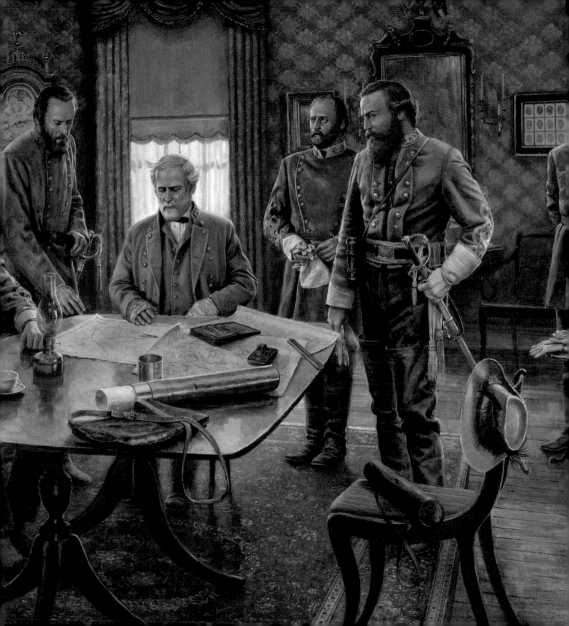

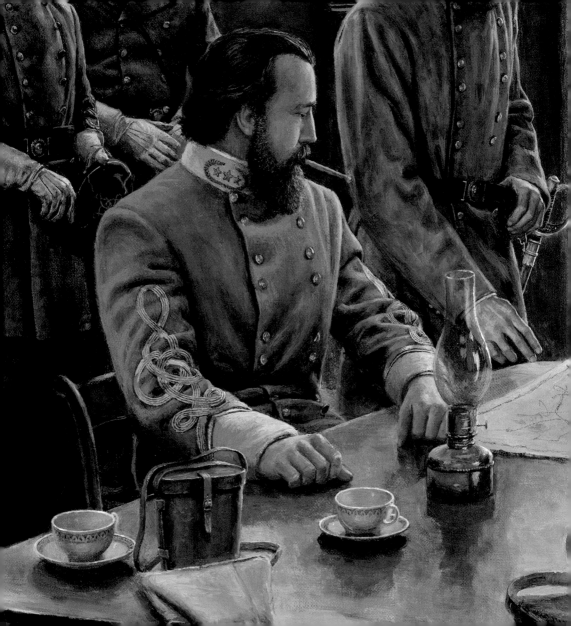

win a major battle on Northern soil—for example, in Pennsylvania—it might be sufficient enough to have the North sue for peace, ending the bloodshed and gaining independence for the South.

In Leesburg, Virginia, Lee's headquarters were established on September 4–5, 1862, at Harrison Hall, a palatial antebellum home, which I visited during my research for this painting. There Lee convened a council of war on September 5 with Thomas J. "Stonewall" Jackson, James Longstreet, Jeb Stuart, and Lewis Armistead in attendance. Lee had injured his hands in a fall from his horse. Longstreet suffered from blisters on his feet, and so he wore slippers to the enclave. Joining the generals were members of Jackson's staff, Hunter McGuire and Sandie Pendleton, on the left side of the painting, and on the far right is Lee's aide, Lt. Col. Charles Marshall. Such a war council—a who's who of Lee's command structure—was rarely assembled.

Lee was again the master strategist and daring risk-taker. He had divided his army to move quickly northward and to secure his rear. Soon the army would be reunited—but until that occurred, it was vulnerable. Lee expected his adversary, George B. McClellan, to move cautiously; he intended to combine his forces before McClellan could detect and exploit this opportunity to strike a hard blow against the invading Southerners.

When I visited Harrison Hall, also known as the Glenfiddich House, it was under restoration, so the interior is not furnished the way I pictured it here. But the fireplace, the floors, and the basic structure are original and today resemble their appearance in this painting. My depiction of the interior wallpaper, rug, drapes, and accessories is based on research into the typical furnishings of the era.

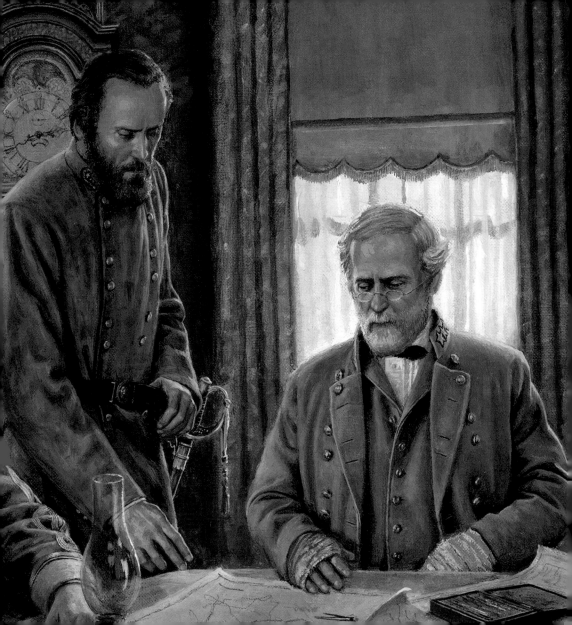

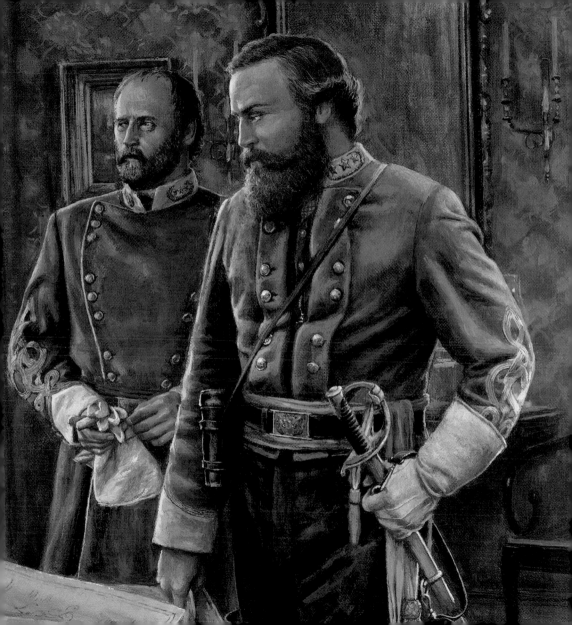

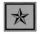

STONEWALL JACKSON AT HARPERS FERRY

SEPTEMBER 15, 1862

1992, oil, 26 x 40

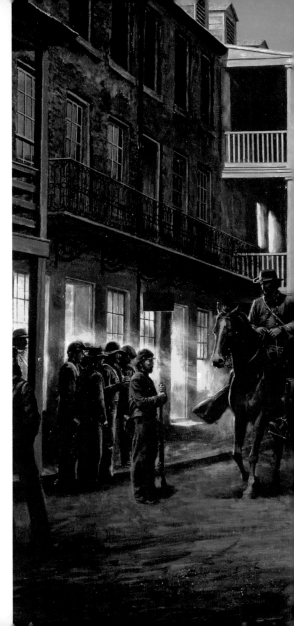

ANYONE WHO has ever been to Harpers Ferry cannot be unaffected by the scenery. Surrounded by soaring bluffs and the Shenandoah and Potomac rivers, the landscape is magnificent. But when one enters the town and sees the preserved and restored buildings of the national historical park, you are instantly transported to the nineteenth century. When I learned that nothing had been painted of Harpers Ferry, I knew I would have to paint it.

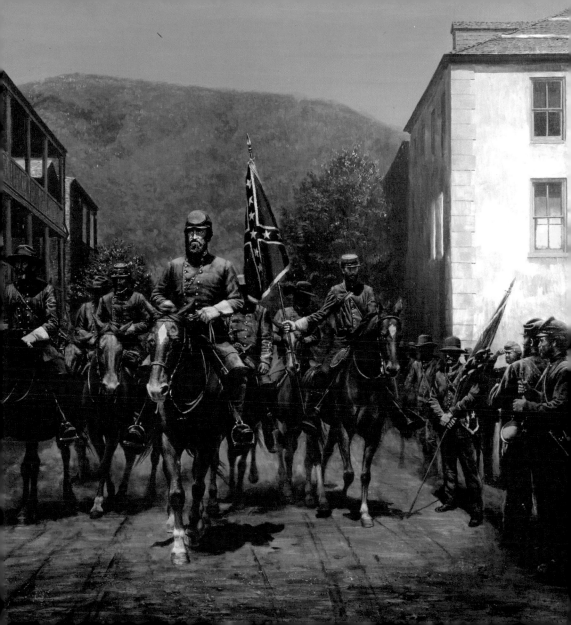

STUDY

1992, oil, 7½ x 11½

In searching through the history of the town, I learned that the capture of Harpers Ferry by Stonewall Jackson on September 15, 1862, had the best possibilities for my canvas. I wanted to paint the buildings of the town rather than outlying scenic areas, and since Jackson marched through the streets with an entourage that evening, I believed this was the perfect picture opportunity. I could paint one of my favorite Civil War personalities within the city and have an interesting lighting effect all in the same painting. By looking up Shenandoah Street, with Maryland Heights in the background, I was also able to incorporate the scenic bluffs.

It had been more than a year since Jackson had been posted at Harpers Ferry. He was somewhat surprised at the level of dilapidation that had set in

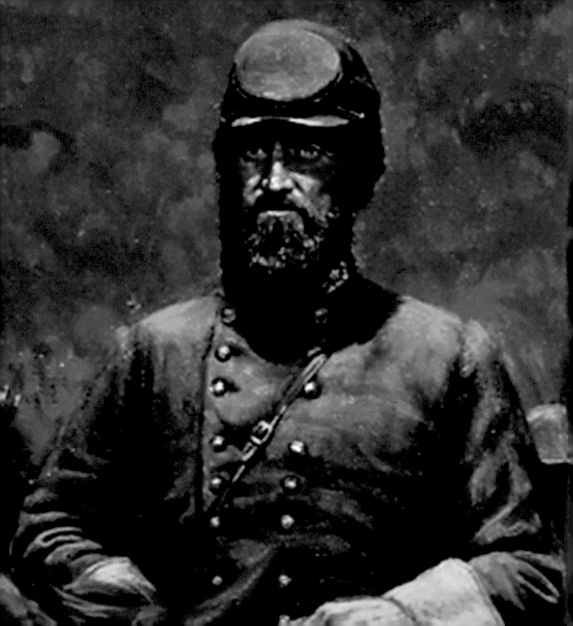

over such a short period of time. Few townspeople were still in residence. To him, it seemed to be more of a ghost town. Once-proud homes had been converted into barracks and stables; charred ruins marked the sites of other homes; and all that remained of the bridges were lone piers in the rivers. But as sad as the sights were to him, he took comfort in the seventy-three cannon, twelve thousand rifles, twelve hundred mules, and two hundred wagons his men had seized. Plus the surrender of more than twelve thousand Union soldiers was the largest of any during the Civil War.

Jackson, naturally, is the center of interest, riding his favorite mount, Little Sorrel. Riding closest to him, on the black horse to the left, is Maj. Wells J. Hawkes. Between them, farther back and to the immediate left of Jackson, is Maj. David B. Bridgford. At the extreme left of the group is Lt. Col. William Allan, chief of ordnance.

The men lounging in the streets are some of Jackson's infantry that occupied the town earlier that day.

Jackson would leave just before midnight for Sharpsburg. Late in the morning of September 16, the lead units of his column reached Sharpsburg.

JACKSON AT ANTIETAM (SHARPSBURG)

GEN. THOMAS J. "STONEWALL" JACKSON,
SEPTEMBER 17, 1862,
9:30 A.M., DUNKER CHURCH

1989, oil, 32 x 50

I HAD been looking for an opportunity to paint Jackson for a second time when a graduating class at the U.S. Army War College in Carlisle, Pennsylvania, asked me to do a painting of Jackson at Antietam as their official print and class gift.

I knew I wanted the Dunker Church in the painting, but I wanted to show many things. Of course, Jackson had to be the center of interest. Since he was on horseback and was all over the battlefield, I could

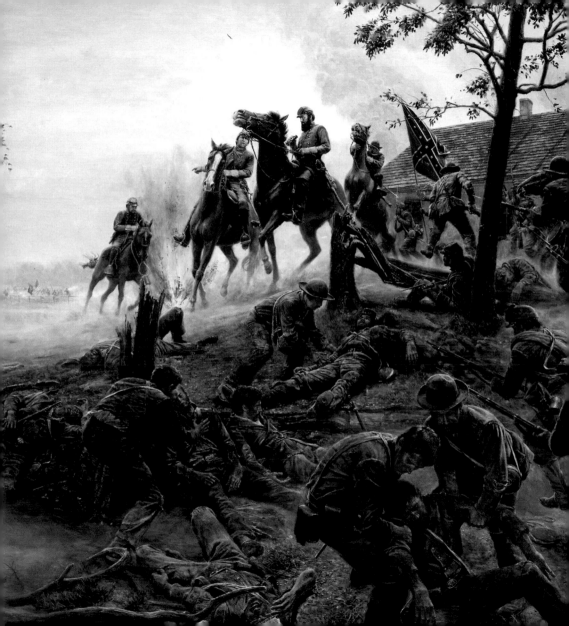

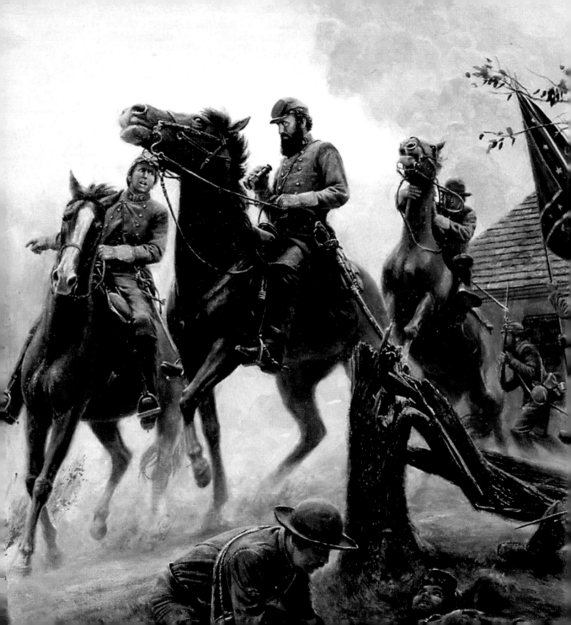

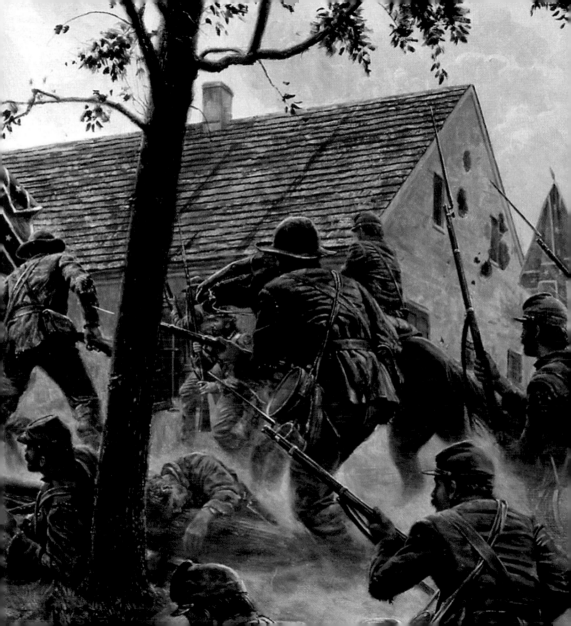

certainly place him near the church, but I also wanted to show the Union troops and the tremendous toll of casualties. After all, this battle was the bloodiest day of the war

After walking around the church, I came across the rocky shelves mentioned in many accounts that were used to shelter the wounded. The final view is from the West Woods behind the church, looking northeast.

The key to the picture is its characterization of the tremendous danger, with Jackson in the midst of this bedlam yet in complete control of the situation. A shell explodes nearby, as Maj. Robert Dabney, of Jackson's staff (center), gallops up with information. Maj. Henry Kyd Douglas points to a developing situation as Lt. Col. Sandie Pendleton's horse rears in reaction to the exploding shell.

The time is 9:30 a.m., and the Seventh Georgia charges around the church to push the Federals back. The arrangement of shell holes on the south side of the church was painted from photographs taken shortly after the battle. Dead and wounded of both sides are all around. On the far left, Confederates charge forward, forcing the eye to the center of interest, Jackson, who remains cool through it all and clearly in control of his horse as well as the battlefield.

The variety of equipment and the sad state of the Southerners' uniforms attest to the difficult times these men have been through. My goal was to convey a feeling of the chaos of the battlefield at this place and time and to capture the calming spirit and dominating personality of Jackson.

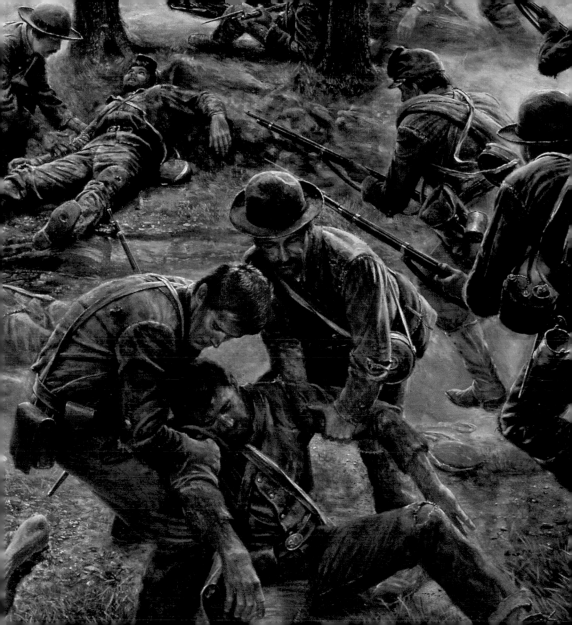

"RAISE THE COLORS AND FOLLOW ME"

THE IRISH BRIGADE AT ANTIETAM,
SEPTEMBER 17, 1862

1991, oil, 30 x 44

ANOTHER CLASS at the U.S. Army War College asked me to do a painting of the Irish Brigade at Antietam. After reading as much as I could on the subject, I went to the Antietam battlefield, timing my visit for an early September morning to be able to see the lighting effects between 10 a.m. and noon. After walking the line of the Sunken Road and through the fields that the Union troops came across, I found the vantage point for the painting. At the extreme right of

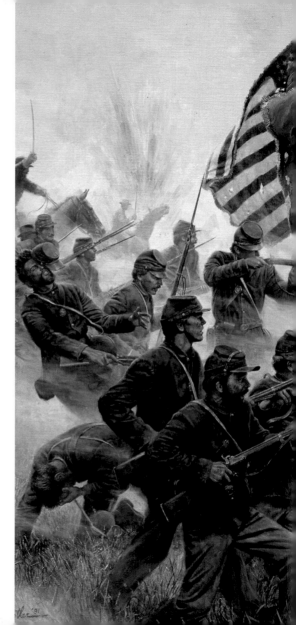

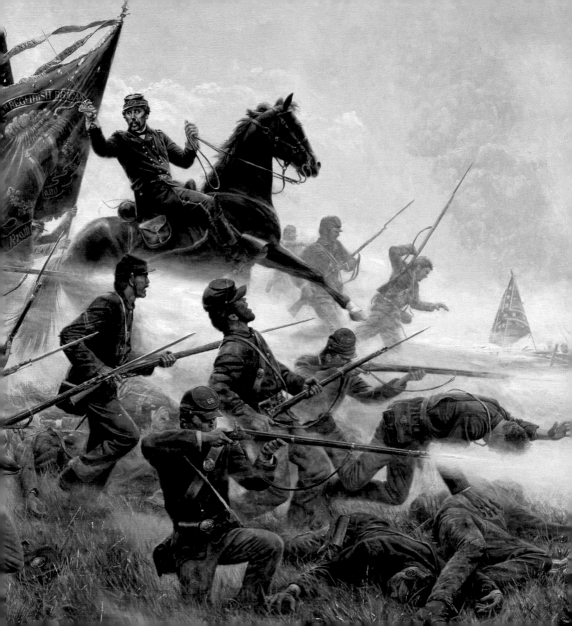

the Union line, there is a downslope to a farm lane toward the northeast. I could use the morning light to dramatically silhouette the distinctive flags of the Irish Brigade, as well as Gen. Thomas Francis Meagher, and also show the Confederate line entrenched in the Sunken Road to the south.

The pleasant surprise for me was that the Sixty-Ninth New York, the first regiment to be raised by Meagher, actually fought at this spot. The troops were equipped with the Model 1842 musket and wore only their belt sets and canteens, having left behind their haversacks, knapsacks, blankets, etc.

Meagher's uniform and likeness are based on accounts and photos. The sword is one of at least four that he owned, a Model 1850 staff and field blade, now in the collection of Notre Dame University.

Ken Powers, historian of the Sixty-ninth, and Barney Kelley, commander of the Veterans Corps of the Sixty-ninth, helped me to learn that the actual flag used at Antietam was preserved at the armory in New York City. We found that, contrary to previously published material on the regimental flag that had shown it emblazoned "69th Regiment Irish Brigade," the flag was embroidered "1st Regt. Irish Brigade."

Bullet holes in the flag in the painting match the battle damage on the original. The streamers also exist, so I was able to paint them accurately.

When Powers and Kelly came to my studio to see the almost finished painting, they brought with them the actual finial from the top of the regimental flag pole that was used at the battle. I, of course, painted the finial to match the solid brass ornament, with one of the small arms broken off. It had originally been silver plated. It was easily the most pleasant change on a painting that was all pleasure from the start.

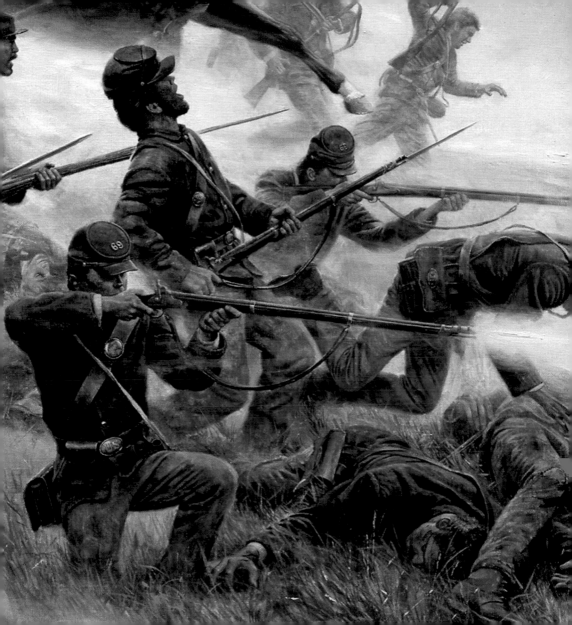

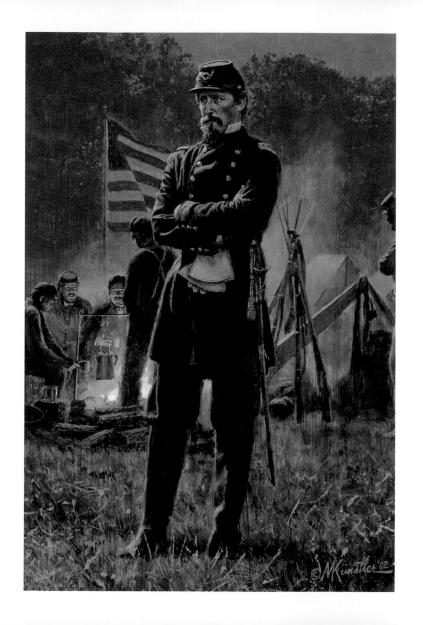

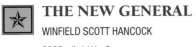

THE NEW GENERAL
WINFIELD SCOTT HANCOCK
2002, oil, 11½ x 8

SO MANY times, Winfield Scott Hancock was there when decisive leadership was desperately needed. He graduated from West Point in the Class of '44 in time to serve in Mexico. Further service followed in the Seminole War, in Kansas, and in California. He distinguished himself at the battle of Williamsburg during the Peninsula campaign, after which George B. McClellan dubbed him "Hancock the Superb." At Antietam and elsewhere, he proved that he deserved such recognition.

In the painting on the next two pages, I chose to portray Hancock at Antietam, where he filled the gap in fallen leadership on the front line. Irish Brigade commander Thomas Meagher and First Division commander Israel B. Richardson were struck down near the Sunken Road. Command then passed to Hancock. This is the deadly, decisive moment I chose to paint. Field glasses in hand, Hancock stands poised in front of the Stars and Stripes. Around him are arrayed the survivors of the battered Sixty-ninth New York, aligned in a defensive position. Fortunately, they were not called upon for any more action that day. Positioned prominently in the center of the painting is the famed green flag of the Irish Brigade.

OVERLEAF ➤

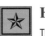

HANCOCK THE SUPERB
THE IRISH BRIGADE AT ANTIETAM, SEPTEMBER 17, 1862
2002, oil, 12¾ x 22⅞

219

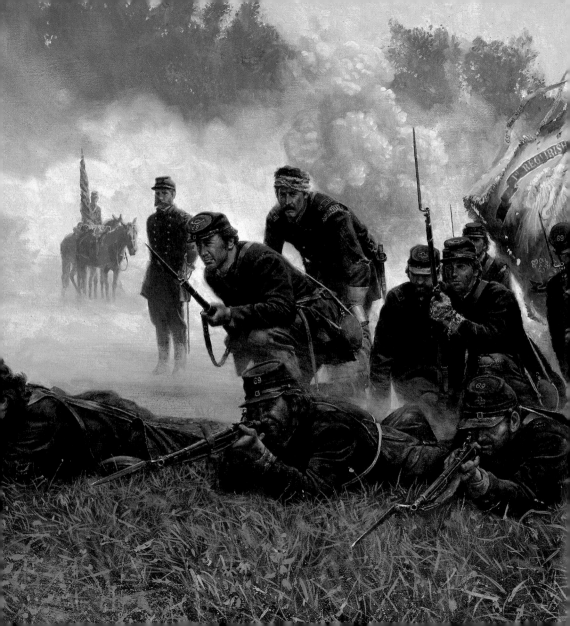

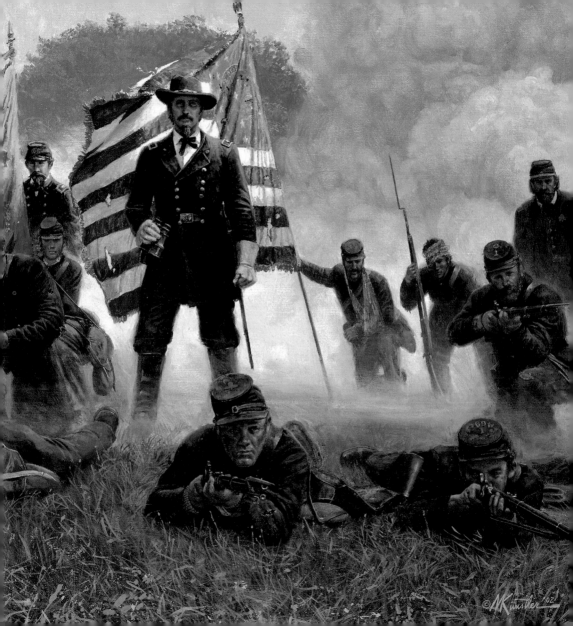

SHARPSBURG WAR COUNCIL

SEPTEMBER 17, 1862

1999, oil, 28 x 42

THE SCENE at Robert E. Lee's headquarters after the battle of Sharpsburg has to rank as one of the war's most dramatic moments. He summoned his commanders to a war council outside his headquarters tent. Should they stay and fight, or should they retreat?

Lee, standing in the center of the group, is pictured as the central and most commanding figure. His hands are still bandaged from the fall he had suffered a few weeks earlier. Leaning over the table is James Longstreet. It was here, this evening, that Lee referred to him as "my old war horse." Directly behind Longstreet are Hood,

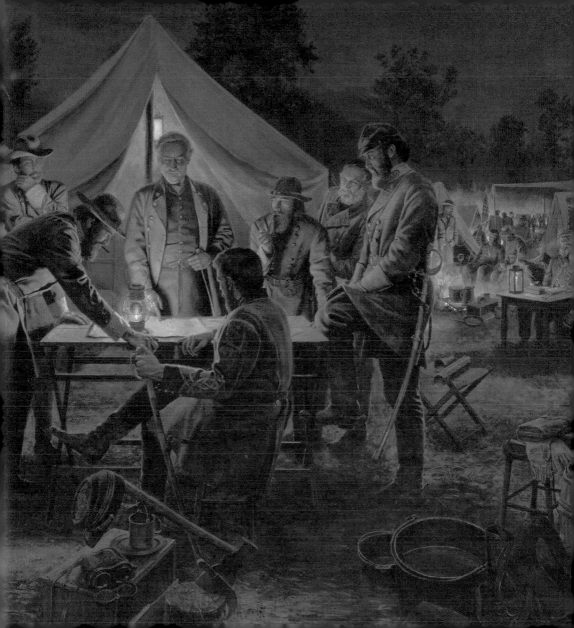

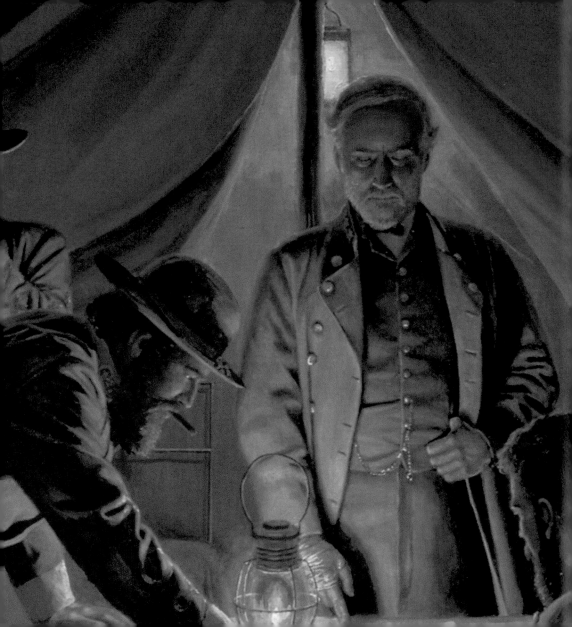

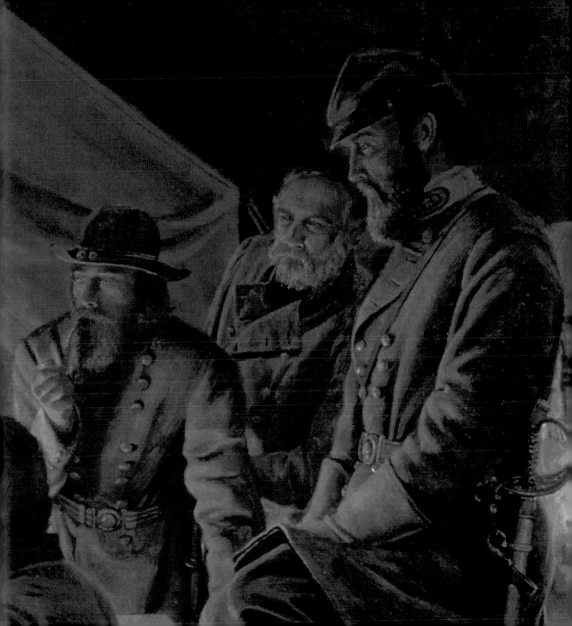

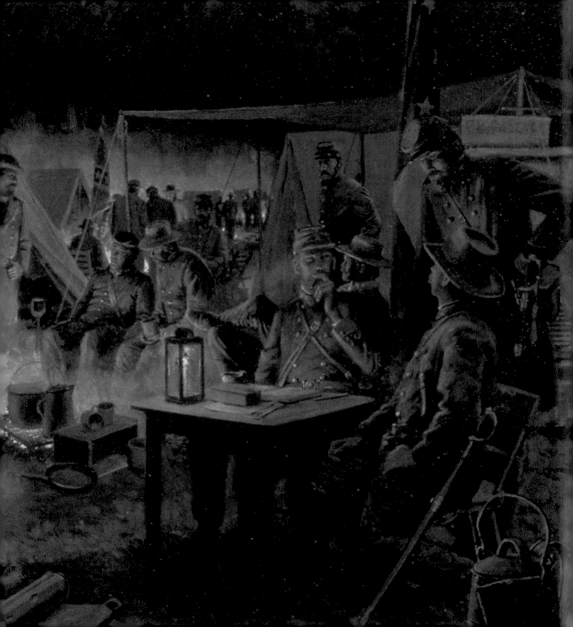

hat in hand, and Daniel Harvey Hill, his hand to his chin. At the opposite end of the camp table is Hill's famous brother-in-law, Thomas J. Jackson, contemplating the proposed strategy. Directly behind Jackson is Jubal A. Early, his hat off. And between Early and Lee is the irrepressible A. P. Hill. Seated with his back to the viewer is D. H. Jones. In the background of the painting are various staff officers, aides, and couriers, discussing the day's events.

I used the lighting to make the painting match the drama of the decision at hand. The lamp in the tent deliberately silhouettes Lee, helping make him the center of attention. All the commanders await his decision whether to retreat or face again the enemy in the morning. In the end, he chose to remain on the field, awaiting the enemy's next attack.

September 17, 1862, had been the war's bloodiest day: more than twenty-six thousand casualties. The Union Army of the Potomac was as battered as Lee's army. It was no surprise that George McClellan chose to avoid further engagements. And so, the day after the bloodiest day was a quiet day. The two armies only glowered at each other; the battle was not renewed.

After sundown on September 18, the Army of Northern Virginia began withdrawing from the field. The invasion of the North had been turned back, and Lee's army had been severely mauled. Despite facing a numerically superior enemy, Lee's legions had held their own—and they would fight again.

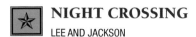

NIGHT CROSSING

LEE AND JACKSON

SEPTEMBER 19, 1862

1995, oil, 24 x 46

detail, right

I WAS rereading Douglas Southall Freeman's matchless biography of Robert E. Lee and came to his account of Lee's army crossing the Potomac after the battle of Antietam. I was struck by Freeman's description of the scene and realized the event conjured in my mind a powerful picture containing several challenging elements: darkness, water, contrasting light. Freeman wrote:

> Steadily through the night and into the morning of the 19th the gray columns passed back into Virginia at the ford a mile and a quarter below Shepherdstown. Lee himself took post at the crossing, to give directions to the teamsters, and when [John G.] Walker's division was over and its commander reported that only his wagons with his wounded and a single battery of artillery remained behind, Lee voiced an audible "Thank God."

I love painting night scenes, and the difficulty of painting the river was a challenge. The torchlight used by the troops is a dramatic contrast to the cool

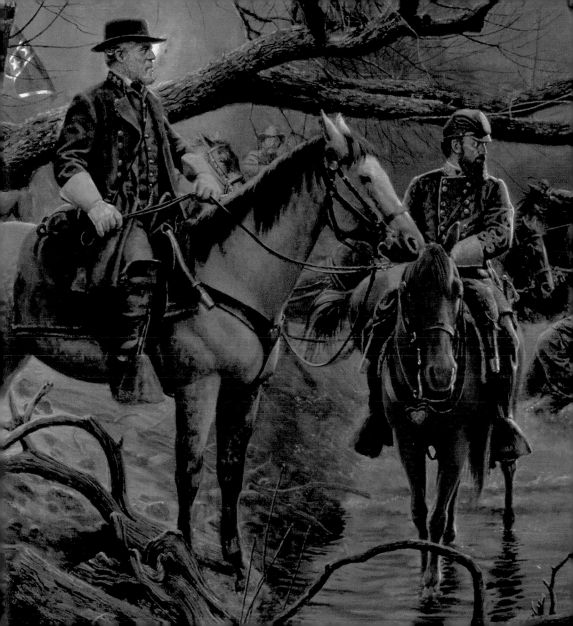

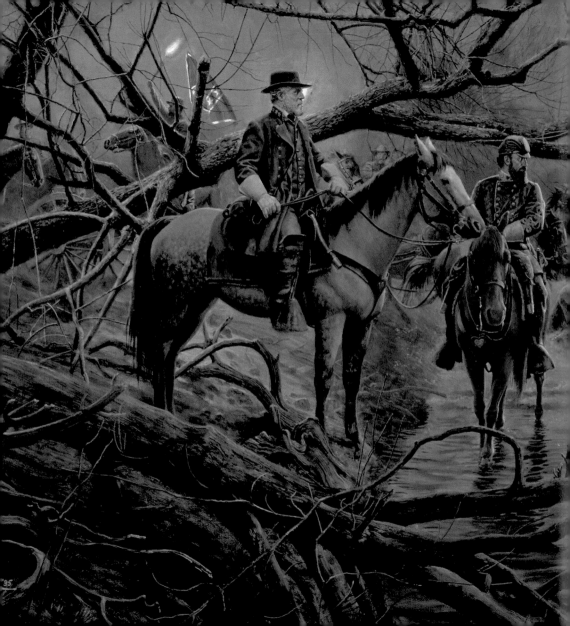

blue light of the night—and that added an additional challenge. And, of course, it was a powerful historic moment. Lee had taken his army to the North with high hopes of winning a great battle that would end the war. Two days after the battle of Antietam, Lee and his army had to again ford the mighty Potomac as they withdrew to Virginia.

There was only one place to cross the river: Boteler's Ford. There the river was three hundred feet wide and knee deep. A thunderstorm passed through the area shortly after sunset, leaving the ground saturated, the riverbank muddy. Jackson's command was the last to cross. Wagons, caissons, and men on the march tangled in the wet darkness.

The scene held great drama, pathos, and energy—horses splashing in excitement, artillery caissons backing up, confusion, chaos—all superintended by a calm, determined Lee. Beside him, Thomas Jackson silently surveys the action while his quartermaster—Col. John Harmon—unsnarls the confusion and supervises the crossing.

In contrast to the energy and action of the background, I posed Lee and Jackson as calm commanders, reflecting the confidence and discipline of their leadership.

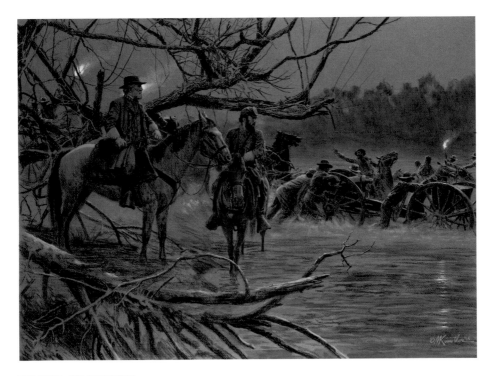

NIGHT CROSSING

STUDY

1995, mixed media, 18½ x 25

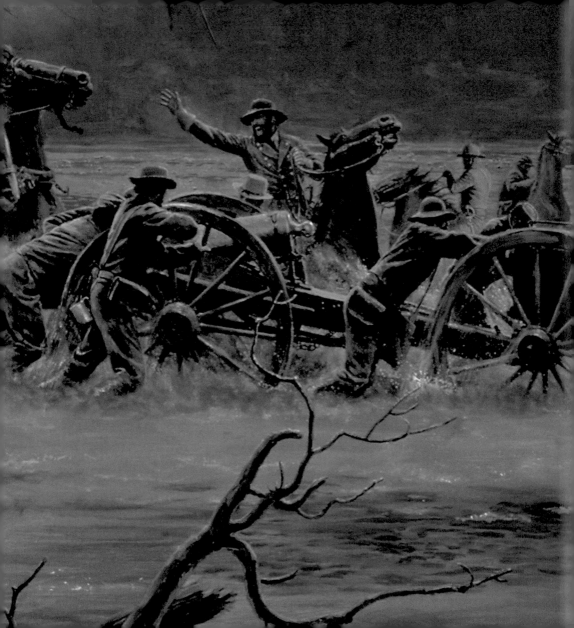

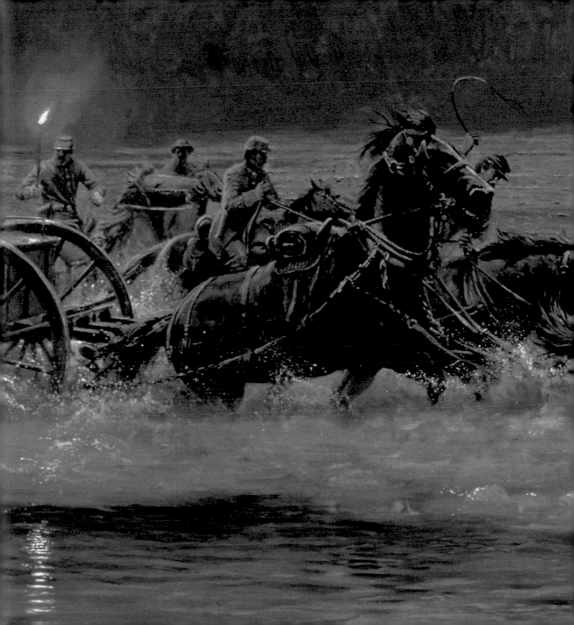

PUBLIC COLLECTIONS

CALIFORNIA

California Museum of Science and
 Technology, Los Angeles
California State Railroad Museum,
 Sacramento
Lowie Museum of Anthropology, Berkeley
Ronald Reagan Library, Simi Valley
San Joaquin County Historical Museum, Lodi
San Mateo County Historical Museum, San
 Mateo

COLORADO

The Air Force Museum, Boulder

DELAWARE

The Hagley Museum, Wilmington

FLORIDA

Daytona Beach Museum of Arts and Sciences,
 Daytona Beach

GEORGIA

Booth Western Art Museum, Cartersville

INDIANA

Midwest Museum of American Art, Elkhart

MARYLAND

U.S. Naval Academy Museum, Annapolis
Washington County Museum of Fine Arts,
 Hagerstown

MISSOURI

Dunnegan Gallery of Art, Bolivar

NEW JERSEY

Hudson County Court House, Jersey City

NEW YORK

Bayville Museum, Bayville
Federal Hall, National Parks Foundation,
 New York City
Hillwood Gallery, C. W. Post Campus, Long
 Island University, Greenvale
Mark Twain Center, Elmira
Museum of American Illustration, New York City
Museum of American Immigration at the Statue
 of Liberty and Ellis Island, New York City
Nassau County Museum of Art, Roslyn
National Art Museum of Sport, Madison Square
 Garden, New York City
Old Orchard Museum, Sagamore Hill National
 Historic Site, Oyster Bay

U.S. Merchant Marine Academy Museum,
 Kings Point
Vanderbilt Museum, Centerport

NORTH CAROLINA

Alamance County Historical Museum,
 Burlington
North Carolina Museum of History, Raleigh
North Caroliniana Society, Chapel Hill

OREGON

Favell Museum, Klamath Falls

PENNSYLVANIA

The National Civil War Museum, Harrisburg
U.S. Army War College, Carlisle Barracks

SOUTH CAROLINA

Charleston Museum, Charleston
Fort Sumter National Monument Museum,
 Charleston
Old Exchange and Provost Dungeon,
 Charleston

SOUTH DAKOTA

Buechel Memorial Lakota Museum, St. Francis,
 Rosebud Sioux Reservation

TENNESSEE

The Hermitage, Nashville
Tennessee State Museum, Nashville

TEXAS

Diamond M Museum, Snyder

VIRGINIA

Museum of the Confederacy, Richmond

WASHINGTON, D.C.

Museum of American History, Smithsonian
 Institute
NASA
National Guard Bureau, Pentagon
U.S. House of Representatives
U.S. Marine Corps Museum
U.S. Navy Memorial Museum
U.S. Secret Service
U.S. Senate

CANADA

The Glenbow Museum, Calgary

GERMANY

Erstes Imaginares Museum, Wasserburg

ART INDEX

ACKNOWLEDGMENTS

Special thanks—

to Ron Pitkin and Ed Curtis of Cumberland House for their foresight, imagination, dedication, and patience in taking an idea and turning it into a reality.

to the renowned William C. Davis with sincere appreciation for his sparkling and informative foreword.

to Dr. James I. Robertson Jr., the celebrated and highly esteemed author-historian. He continues to be an unending fountain of information as well as a dear friend.

to author-historian Rod Gragg, who for fourteen years has been my adviser and good friend, making me the beneficiary of his infinite wisdom and knowledge.

to Richard Lynch, president of Hammer Galleries in New York City, who gave me my first one-man show in 1977. Thirteen exhibitions and a lasting friendship have followed. My deepest appreciation to Howard Shaw, vice president, and the rest of the staff at Hammer Galleries for all their efforts on my behalf.

to Chris Brooks, of American Spirit Publishing, the exclusive publisher of my limited-edition fine-art prints, for his knowledge and commitment to excellence.

to Paula McEvoy and Lissette Portillo of Künstler Enterprises, for their enthusiasm and dedication in managing the daily operations of a busy studio. I could not function without them.

to my daughter, Jane Künstler Broffman, who headed this project, sharing her knowledge, advice, and creativity on a daily basis. I am delighted to be able to work with her and truly appreciate her expertise.

especially to my beautiful Deborah, my partner in every way, for her cheerful attitude, words of wisdom, and infinite patience. She has truly been the "wind beneath my wings."

—Mort Künstler